C000118346

IMAGES OF ENGLAND

Minehead to Watchet

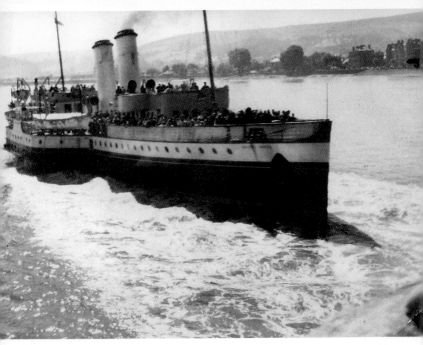

The *Bristol Queen* off Minehead in the 1960s, the last of the Campbell White Funnel paddle steamers that plied the Bristol Channel for eighty years, beginning with the Waverley in 1885. Some of them sailed these hazardous waters for more than sixty years and gave military service in both the world wars. The *Bristol Queen* was built to a new and well-researched design soon after 1945, and it was written of one of her cruises: 'It was a marvellous, clear, calm, moonlit night; very few passengers; the rapid, powerful beat of the paddles giving a true impression of speed yet an air of peace; the tall raked white funnels reaching up to the sky.... The sheer joy of it was almost unbearable.'

IMAGES OF ENGLAND

Minehead to Watchet

Glyn Court

NONSUCH

Front cover illustration: Horse races on the beach at Minehead, 1906.

First published 1996
This new pocket edition 2006
Images unchanged from first edition

Nonsuch Publishing Limited
The Mill, Brimscombe Port,
Stroud, Gloucestershire, GL5 2QG
www.nonsuch-publishing.com

Nonsuch Publishing is an imprint of Tempus Publishing Group

British Library Cataloguing in Publication Data.
A catalogue record for this book is available from the British Library.

ISBN 1-84588-297-0

Typesetting and origination by Nonsuch Publishing Limited
Printed in Great Britain by Oaklands Book Services Limited

Contents

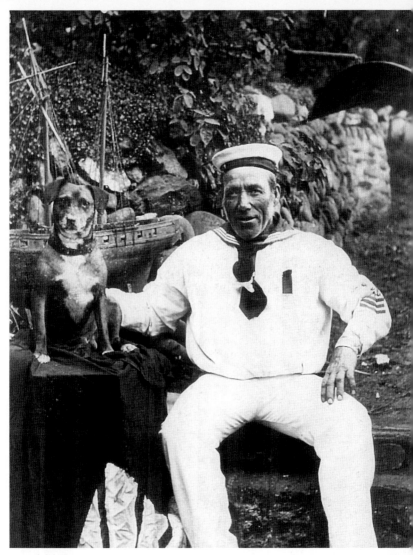

James Pearl, coastguard, was born in Harwich in 1837 and joined the navy at the age of 23. When discharged at 38 with three good conduct badges he was transferred to the coastguard at Minehead. He was promoted commissioned boatman in 1878 and pensioned on his fiftieth birthday. The model behind his dog is probably of his first ship, HMS *Pembroke*.

Just a line from West Somerset! J.H. Martin Cross, a talented producer-director, enjoyed considerable local popularity around 1930 with films in which Scouts met with adventures and foiled malevolent villains. In *Scouting Wins Through* the hero, chased by a gang, tries to get away by hauling himself hand over hand on a rope slung over Cheddar Gorge. They cut the rope and he is injured, but recovers, returns to the attack and lands the gang safely behind bars. Moral: You can't keep a good Scout down!

Introduction

Just as the whole of rural England, but for the northern lakes and mountains, is mirrored in miniature in the hills and heathland, moor and pastures of Somerset, so is the county as a whole reflected in its western part, with Exmoor rising to 1,700 feet, slightly lower green hill-pastures, and a sea marsh which lacks Sedgemoor's air of mystery but is still deservedly part of a Special Landscape Area.

Nine out of ten visitors to West Somerset come by road, either by the A39 skirting the north of the Quantock Hills or by the A358 on the south. After a long climb on either road they come suddenly to the top of the rise and there, spread before them, is a breathtaking prospect of sea and plain, ringed in the distance by lofty purple hills. That coastal plain, with its immediate hinterland, is the area covered in this book.

Two of the main roads into West Somerset struggle up to 1,000 feet above sea level, and all the others rise to at least 400, so that the district has always been very much a place apart. Its inhabitants have always taken pride and pleasure in viewing their home in that light and seeing themselves as a 'different' people, drawn in sympathy toward the uplands of Exmoor and the Brendon Hills rather than the prosperous towns and villages of Taunton Deane.

A hundred years ago these feelings were even stronger than now, and many scenes in the rural areas were so 'different' as to be unique. By great good fortune many of these were recorded by a succession of artists and photographers. Among the former were Sir Hubert von Herkomer, J.W. North, Robert W. Macbeth and Frederick Walker; and among the latter were local practitioners with a genuine sense of style such as the Hole family of Minehead and Williton, James Date of Watchet, Daniel Nethercott of Roadwater, Frederick William Vickery of Luxborough, and John Palmer of Skilgate. In the next generations local scenes were recorded by A.Cranmer, G. Richardson, Kingsley Tayler and Alfred Vowles or appeared on the postcards of the firms of Frith, Judge and Valentine, or in some of the two thousand delightful watercolours painted by A.R. Quinton for Salmon of Sevenoaks.

All these photographic artists are represented in this collection, together with a commentary based on a half-century's acquaintance with the district and its personalities, history and legends. Some readers may feel that the villages figure disproportionately to the towns, but so many of the present inhabitants of the towns have come in from the villages in the past fifty years that they need only turn the page, so to speak, to find themselves in the country of their childhood.

A comprehensive collection would take a score of books of this size, and the very wealth of material has made selection and rejection a task of great pleasure mingled with greater frustration – pleasure at the good company, both past and present, encountered in my researches and frustration at having to leave so much out! This book appears as part of the Archive Photographs series, and uppermost in my mind has been the thought that our heritage as a nation, and as this microcosm of a nation, consists not only in the works of hand and brain – art, books, buildings, landscape – that have been left us by a score of generations, but also in the memories and records of men and women who, before the coming of photography, worked and played in their generation but left no trace of their passage through the world save in the short-lived memory of their immediate families and in the dwellings and landscape they created.

The camera changed all that. The face of a ploughman could endure as long as that of a king, and Richard Jefferies' lament that 'the faces fade as the flowers, and there is no consolation' lost a little, if only a little, of its poignancy. That is why I have taken particular care to identify, wherever I could, the men and women who appear in these old photographs, in the hope that some readers will be reminded of happy times long ago, and others will take pleasure in discovering long-lost and far-distant relations in whom they can see the lineaments of themselves and feel a justified pride.

One

Minehead
A Stroll through the Town

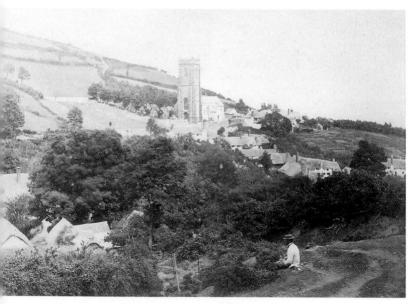

St Michael's and Church Town from North Hill, c.1870.

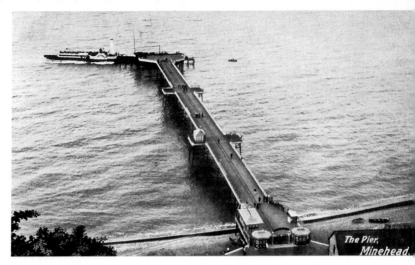

Minehead Pier played an essential part in the town's development as a holiday resort. It was opened in 1901, and for nearly forty years it served the steamers which brought day-trippers, several hundred at a time, from the industrial areas of South Wales – not a few of them to visit the scenes which their parents or grandparents had known. Then, in the 1940 summer of blitzkrieg and Dunkirk, the pier was demolished in a frenzy of military incompetence for fear it might block the field of fire of a 4-pounder.

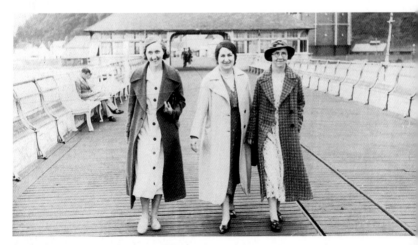

Rose, Alice and Marjorie Rawle enjoy a breezy day on the pier, c.1930. Note the tip-up seats lining the rails.

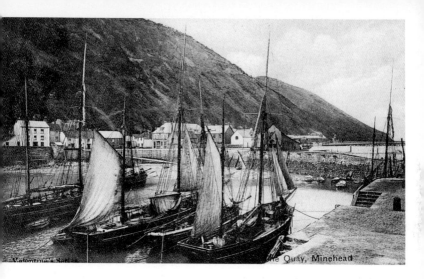

Above: Minehead Quay with boats, 1890s.

Right: G. Richardson's photograph (c.1900) of a herring boat at Minehead Quay has something of the quality of the paintings of Cornish fishing ports by Birket Foster or Noel Titcomb a few years earlier. Herring were the staple catch of the Minehead fishing fleet for hundreds of years, but in the 1920s the shoals moved away or dispersed and the fleet declined almost to nothing.

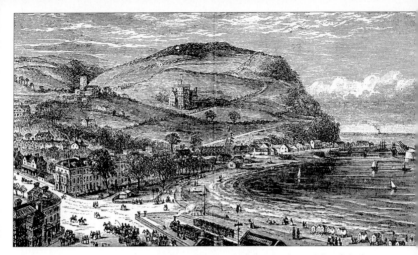

Minehead sea front in the late 1870s. The railway reached Minehead in 1875 and the luxurious Metropole Hotel and the Beach Hotel were opened in anticipation of a surge of visitors. Bathing machines for ladies satisfied the demands of modesty, and the mansion of Elgin Tower signalled that the lower slopes of North Hill lay open for development. In front of the pleasant row of coastguard cottages (centre) stands a semaphore.

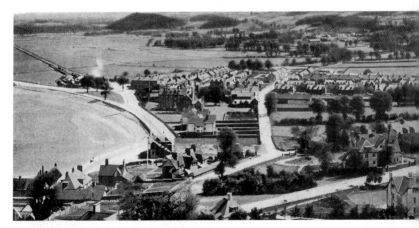

The sea front seen from North Hill, c.1900, before the start of the season and giving the impression of a town aiming for elegance. The land east of the railway station is free of building, and pleasant open country separates Alcombe from the eastern edge of Minehead (now about Mart Road).

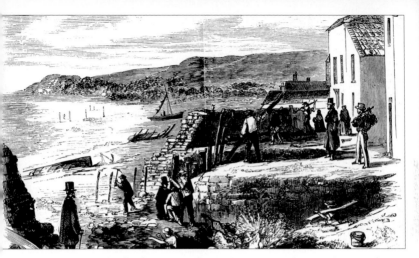

The sea has been Minehead's adversary as well as her benefactor. Back in October 1857, during the famous Royal Charter Storm, its attack was even reported in *The Illustrated London News*: 'From about noon, torrents of rain descended continually, accompanied by a strong wind E.N.E., which increased to a heavy gale. One coaster after another won its way into the harbour, one with its sails blown into ribbons; but even within the pier the sea was tremendous, and several vessels were greatly injured, as they could not be moored securely, and struck against each other. Broken boats and masts of wrecked vessels strewed the shore. The most remarkable effects of the storm, however, were shown in the quay wall and the road inclosed by it.... The violence of the waves increased until they reached the height of the houses, much to the alarm of the inhabitants, breaking down the sea wall and washing away the road in two places to within two or three feet of the doors. The houses were flooded to the height of three feet, causing much loss to the poor inmates, chiefly women, whose male relatives were occupied in trying to save their boats or their employers' vessels.' The gentleman on the right in Abraham Lincoln's hat was most probably the agent for the Luttrell estate.

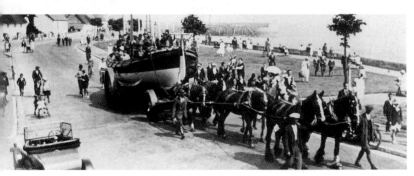

Lifeboat in Quay Street, *c*.1935.

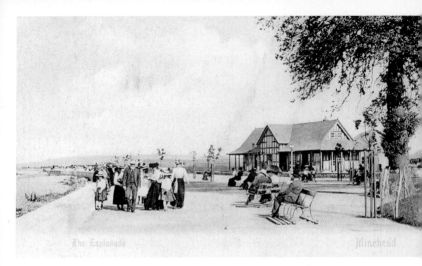

The Promenade, 1904, very uncluttered and obviously a pleasure to stroll on.

The Avenue, lower end, c.1900, with carriages waiting to pick up passengers from the station. The string of horses is being taken back to the mews in Northfield Road.

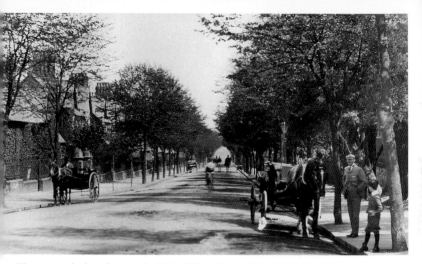

The Avenue, looking down, early 1900s. Well within the living memories of contemporaries this had still been a walk by an open brook, beautiful and very agreeable in fine weather but liable to overflow in winter.

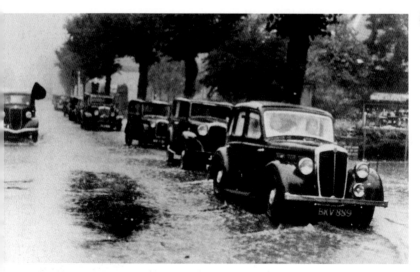

Minehead has rarely been flooded so spectacularly as Williton or Washford, but this scene by the corner of the Avenue and Northfield Road in 1935 has been repeated, give or take a car or two, several times since, and as recently as 1994.

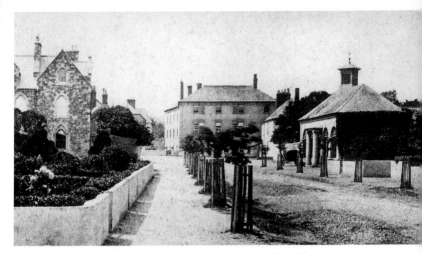

The Parade, Minehead, about 1885, which name replaced the old Puddle Street, for the town was just beginning to modernize itself and 'tiddyvate' itself up. The trees in this picture were planted, presumably to make an avenue, but they were not allowed to grow to full maturity. Not long before, a pretty but capricious brook had run down the middle of the street, but it had been culverted to keep it in order.

About ten years later. From the look of the workman in the Square, demolition and rebuilding are going on.

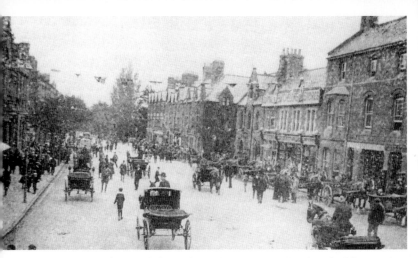

The Parade, c.1910, still a jay-walker's paradise, with not a car in sight. The splendid tree at the far end, by the Priory, was still standing defiant.

The same again, in 1942, adorned with one of the twentieth century's unique achievements, the air raid shelter – fortunately never used in earnest.

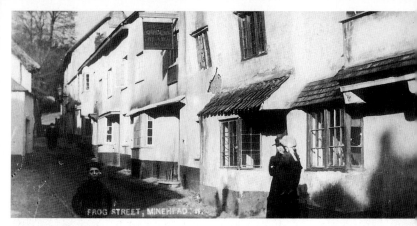

Frog Street in the 1890s, so called from its residents and frequent visitors from Watery Lane. Just visible is the short flight of steps leading to the Hollow Way.

The home of Edmund George Hill at No. 7 Frog Street, by Tythings Court, decorated for the coronation of George V – and rather tastefully, in keeping with his sale of artists' materials. E.G. Hill had been a house decorator at this address since 1890, when he moved from Nether Stowey seeking to better his prospects, but he seems to have practised professionally as a photographer for a good many years before. His son, Murray Hill, became a leading figure in Minehead. He served in the First World War, acquiring seventeen wounds from shrapnel, and commanded the Minehead Home Guard from 1940 to 1942 when he left to take up a government appointment. The house next door was the Dewars' barber shop. Their only son, William, started the building firm W.E. Dewar, later Dewar and Murrell.

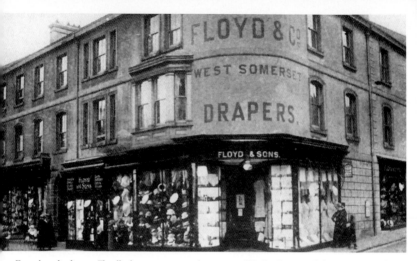

For a hundred years Floyd's drapery store on the corner of Friday Street and the Square was the magnet that drew country housewives to Minehead, the emporium from which few came away empty-handed. Until quite near the end it retained the old prices, charging, say, 'Four-and-eleven-three' with a packet of pins for the farthing change from five shillings. The delight for children – and no one who saw it working can ever forget it – was the intricate network of overhead wires by which your half-crowns and florins were conveyed in little sealed cups with a 'whirr' and a 'swissh' from every corner of the shop to the cashier in the centre, and the receipt sent back with a 'whirr' and a 'swoosh' and a 'clunk' as the little aerial gondola reached its journey's end.

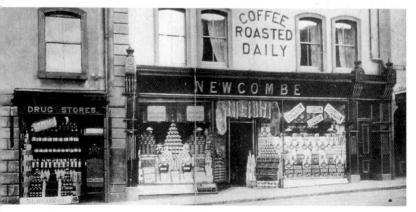

Newcombe's Stores and Cafe in Friday Street, next door to Floyd's. In the 1930s Minehead was able to support three good tea-rooms with bakery and confectionery: this one, Boddy's on the Parade, and Bagley's in Park Street.

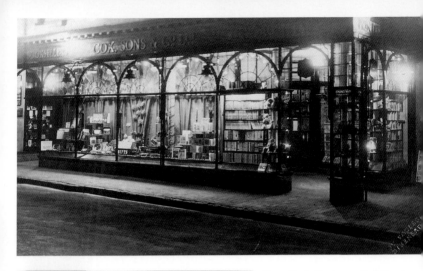

Above: Cox's, Stationers, Park Street and Wellington Square, brilliantly lit in its heyday. (Photo by Alfred Vowles)

Left: Church Street, Minehead, on Oakapple Day (29 May) 1895. Oak branches were placed at cottage doors in belated (and some might think misguided) celebration of Charles II's concealment in the Boscobel Oak. This custom is – rather surprisingly – still maintained in one corner of Minehead. Another custom dictated the wearing of an oakapple as a button hole on that day, and up to the 1930s little Royalists took delight in whipping unadorned little Roundheads across the back of the legs with bunches of stinging nettles. This custom has lapsed.

Two

Minehead
The People

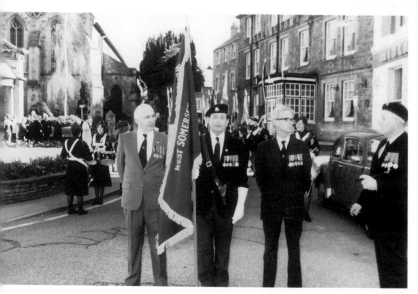

Burma Star contingent from Minehead and the surrounding district parade for the dedication of the standard, 1988.

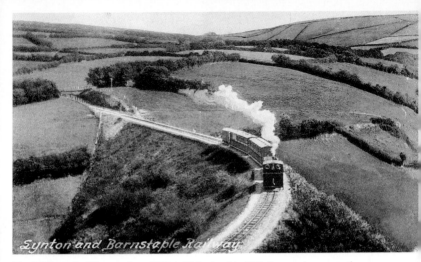

The GWR reached Barnstaple in 1873 and Minehead in 1874, but another twenty-four years passed before a small local company took the line on from Barnstaple to Lynton. The Lynton–Barnstaple line cost double the forecast to build, came too late in the day to compete with motor transport, and attracted more sentiment than custom. It was closed in 1933.

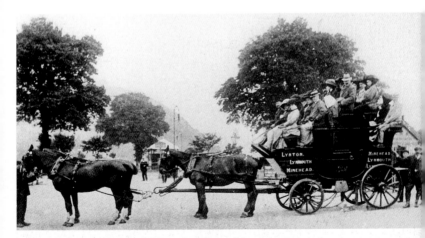

Lynton is only nineteen miles from Minehead by road, but eighty-six by rail, an inconvenience 'up with which most travellers were not prepared to put!' Motor buses had virtually superseded horse-drawn coaches by 1920, but they could not always grind their way up the hills of the Exmoor coast, and so the Minehead–Lynton four-in-hand remained in service until 1923. This shows the Lynton coach on the sea front, c.1900.

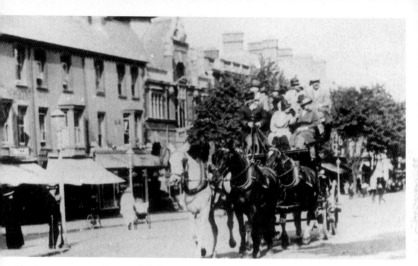

The Lynton coach at the top of the Parade.

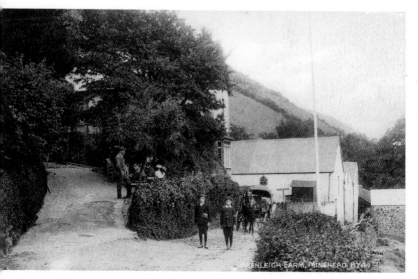

Greenaleigh Farm, an easy stroll from the pier and famed for Mrs Rawle's cream teas.

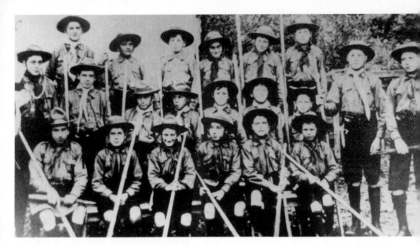

Minehead Scouts, 1910. Back row: R. Parminter, H. Baker, P. Lyddon, P. Rawle, H. Boatfield, J. Parminter, L. Jones, W. Dewar, G. Harrison, H. Folley. Middle row: T. Collins, D. Bryant, W. Dyer, A. Webber. Front row: -?-, G. Slade, W. House, H. Bushen, P. Simons, E. Adams. The names of two of these twenty lads, H. Baker and G. Slade, appear on the Minehead war memorial, but the rest seem to have come through and, one hopes, lived to bring up families.

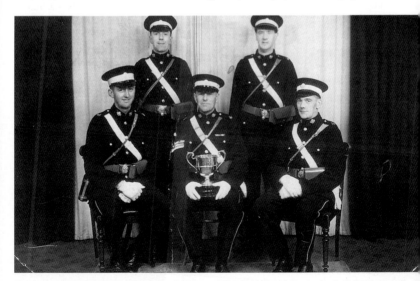

St John Ambulance team, champions of division, 1930. Back row, left to right: Jack Rawle, ? Pring. Front row: Ken Bailey, ? Jones, Ted Lamb.

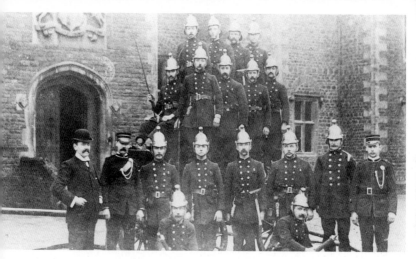

Minehead Fire Brigade at Dunster Castle, 1898. Back row: N. Harrison, F. Vickery, W. Court, T. Vickery. Middle row: Noah Boatfield (horse driver), W. Lockyer, J. Croote, C. Webber, H. Baker. Front row: Mr Ponsford, W. Tarr (Capt), W. Moggridge, R. Newton, H. Prescott, M. Webber, A. Wheelock (Vice Captain). Kneeling: Sid Webber, Jim Reed. The Minehead men were emulating the Dunster Castle Brigade, who had paraded for the first time in May of the previous year in new uniforms bought with the aid of grants from insurance companies and advice from the London Fire Brigade, all to smart and striking effect.

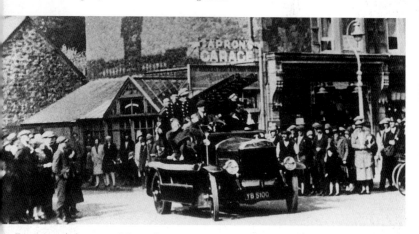

Fire engine dashing out of Capron's Garage, c.1920. The Capron family were involved with fire fighting for half a century, after John Capron and his son Mark took a hand pump to a fire at the tannery in 1867.

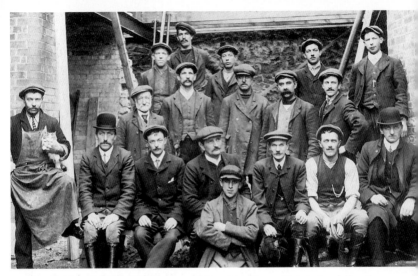

Building Staddons Garage, c.1910. Front row, left to right: Tommy Slade (painter), Tom James, Edward Rawle, Archie Staddon, Sid Priscott, Walter Badcock, -?-, Percy Staddon. Middle row: second from left: Frank Phelps (carpenter).

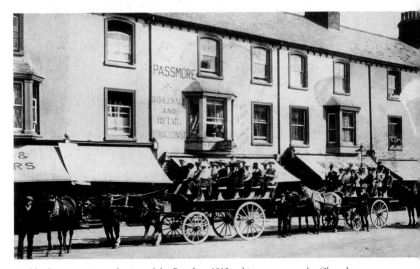

Staddon's wagonettes at the top of the Parade, c.1912, taking a party to the Cloutsham meet. Percy Staddon is driving the first, Edward Rawle the second.

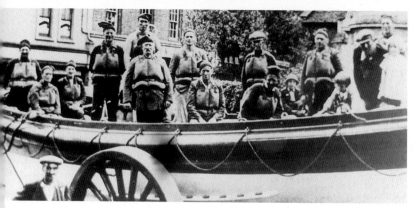

Lifeboat in Wellington Square, *c.*1930. Left to right: James Martin, Alfred Webber, William Slade, Roland Bushen, Lionel Bushen, Frank Bryant, Herbert Dyer, Leslie Rawle, Harold Bushen, Edwin James, Joan James, Sidney Lone, Billy Bushen, James Bushen jun, James Bushen sen, Joan Bushen.

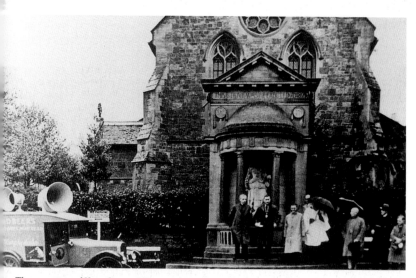

The accession of King George VI is announced on a dank Saturday morning in December 1936 following the abdication of his brother. The Town Clerk is standing in front of the statue of Queen Anne which was given to the town by an eighteenth-century MP and kept in the parish church till 1898. It was then transferred to this site, outside the new St Andrew's and opposite the Plume of Feathers Hotel, which led one grave and reverend senior to comment, 'There she is, th'ole queen, wi' her face to the pub an' her a—e to the church.'

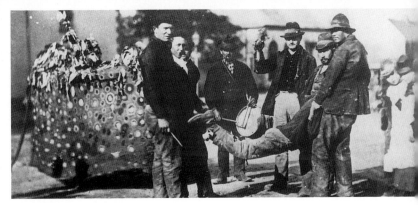

The hobby horse in 1870. Guided and supported by guizers and mummers and a musician, he still caracoles through the streets in the first week of May, as he has done since time out of mind. It may be fanciful to suggest that his name connects him with Hubba, the Danish chieftain who raided along this coast in the reign of Alfred the Great, but given the tenacity of folk memory, his weird appearance and painted circles may very well embody a memory of the shields along the upper wales of the Viking longships which struck such terror into the hearts of dwellers along the coast a thousand years ago. Both the areas which preserve the hobby horse – the West Somerset coast and Padstow – suffered grievously at Viking hands. The young man slung between the two pillars of rectitude is about to be barbarously 'bumped'.

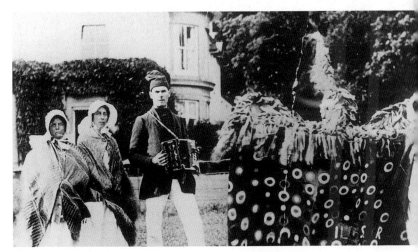

Hobby horse at Flook House, Taunton, 1920, with, left to right: G. Bruford, A. Burgess, W. Webber, J. Heard, B. Escott and C. Harrison.

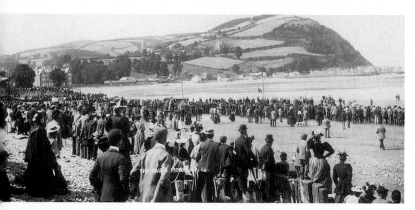

Horse races on the beach, 1906, when, according to the press, a good time was had by all, not least the merry pickpockets.

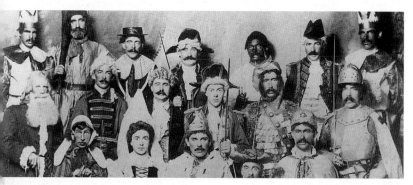

The Christmas Mummers' Play must go back several hundred years, with St George as its hero and Turks as its villains, for seafaring men, including one lad from Minehead, were often enslaved by Barbary pirates. In time other characters of legend crept in, such as Nelson and King John! The performance in the Public Hall by the 'Guild of St George' was of course a revival. In *The Return of the Native* Thomas Hardy describes a performance of a mummers' play almost identical with this, and comments, 'A traditional pastime is to be distinguished from a mere revival in no more striking feature than this, that ... the survival is carried on with a stolidity and absence of stir which sets one wondering why a thing that is done so perfunctorily should be kept up at all,' but 'in the revival all is excitement and fervour' – even if a posed photograph does not convey exactly that impression! Back row, left to right: J.R. Passmore (1st Mummer), S. Mason (Giant Beelzebub), W. Graddon (General Wolfe), W. Webber (Sambo), R. Upham (Admiral Duncan), Bryant (2nd Mummer). Second row: J. Parsons (Old Father Xmas), J. Reed (Slasher the Valiant Man), Mr Kille (Doctor), F. Wood (Lord Nelson), H. Harrison (Turkish Knight), -?- (St George). Front row: ? Kille (Dame Dorrity), J.K. Webber (Queen Susan), G. Chapman (King John), ? Howard (Little Man Jan), W. Simmons (Valentine the Morocco King), G. Arthur Mason.

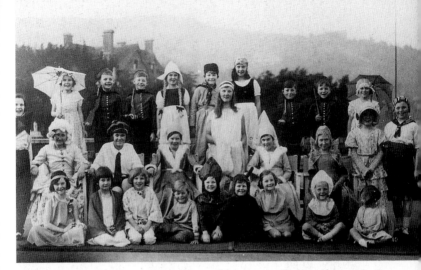

Children's Pageant, 1932, on the roof of Newcombe's restaurant. Back row, left to right: Peggy Thorne (Hawkins), Charles Bryant, Jack Hosegood, Joan Davey. Middle: Carole Holdsworth, Joyce Phillips, Pat Cox, Muriel Bentley. Front: Monica Hornby, Michael Hosegood, Noel Blyth, Bettina Chidgey.

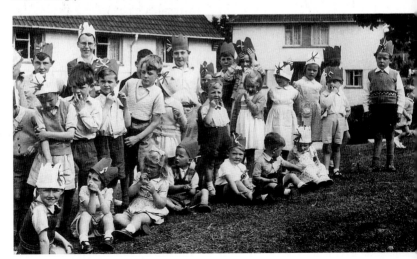

Coronation Day party for the children on the Periton estate, 1953.

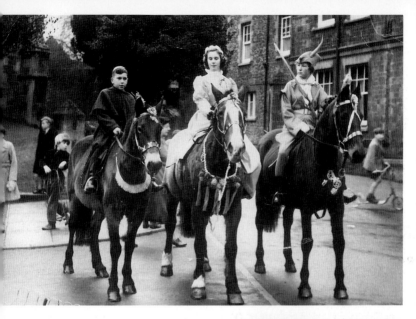

Above: Christmas Ride from edge of town to Minehead Hospital, 1959 or 1960, led by (left to right) David Rawle, Vivienne Irwin and Pat Townsend.

Right: Murray Hill, son of E.G. Hill, painter and photographer (see p.18). He served in the Somerset Light Infantry in the First World War, recovered from multiple shrapnel wounds and took leading parts as a singer and actor in many productions of Gilbert and Sullivan by the Minehead Amateur Operatic Society. In the Second World War he commanded the Minehead Home Guard as a major. Here he is, of course, Major General Stanley in *The Pirates of Penzance.*

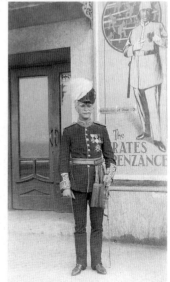

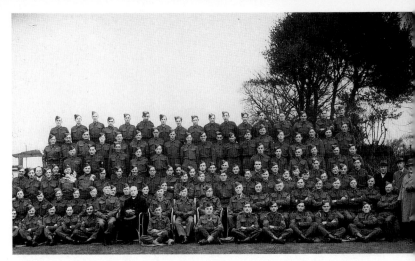

Minehead Home Guard, 1943. Back row, left to right: 1st Poole. Second row: 1st Arthur Newton, 6th Bill Martin, 7th Clarence Venn, 13th Stone (Swimming Pool), 14th A. Vowles. Fourth row: 1st H. Kille, 2nd C. Foy, 4th Monty Cole, 17th Jennings, 18th Gussy's father. Fifth row: 1st Willis, 2nd Elston, 3rd Tony Badcock, 4th Corney. Front row: 1st Laidlaw (Nat Bank), 2nd Bartlett (butcher), Lord Cromer (sitting next to padre), Reg Holmes (sitting on ground at end), Fred Stevens (Strand Restaurant) sitting on chair. Also in this row are Kingsley Tayler, Coleman and C. Newcombe. Seated centre is Murray Hill, Commanding Officer; standing behind him are Henry Snell and, three places to his right, Noah Atkins CSM.

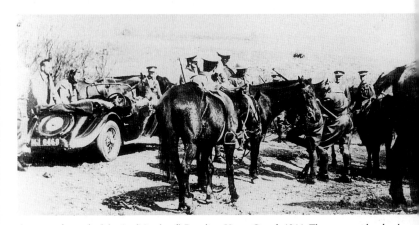

A mounted patrol of the 1st (Minehead) Battalion Home Guard, 1944. They were said to be the only home service unit still equipped by the War Office as genuine cavalry.

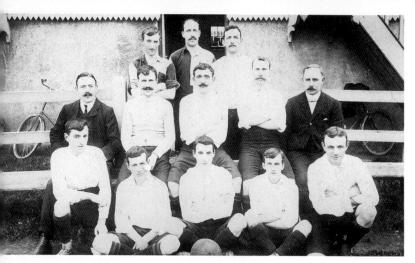

Minehead Wednesday football team, 1904-05. E. Perry, H. Chidgey, P. Staddon, Mr W.R. Hunt, W.R. Webber, A. Willis, A. Lovelace, Mr W. Boddy, F. Giles, C. Forrest, W. Upham, R.E. Floyd, T. Bass.

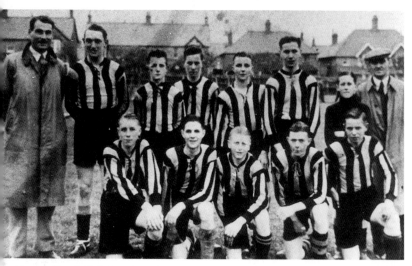

Minehead Football Club, 1937. Back row, left to right: Wm Corney, Basil Pugsley, Nolan Elston, Leslie Clatworthy, Sydney Land, Wm Hawkes, John Hewett, Frank Rice. Front row: Stanley Rawle (later harbourmaster), Charles Uppington, John Moore, George Hewett, Jack Griffiths.

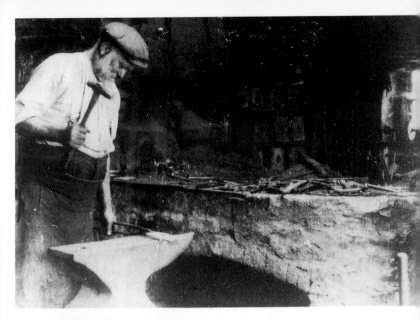

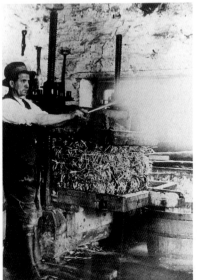

Above: William Henry Sparkes at work in his smithy in Middle Street in the early 1900s ...

Left: The smith died in 1916, and afterwards his smithy served for cider-making in the traditional way: apples were pressed under layers of straw, with maybe an incautious rodent in the pomace to give it 'body', and no namby-pamby nit-picking over hygiene.

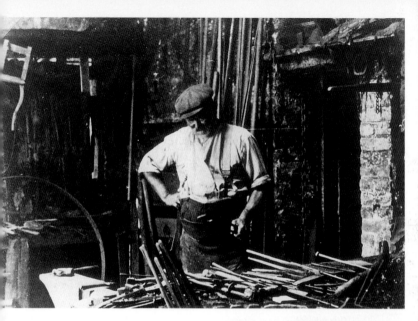

Above: ... and resting from his labour and finding it good.

Right: An extract warranted to turn the head and tangle the feet of the hardiest imbibers.

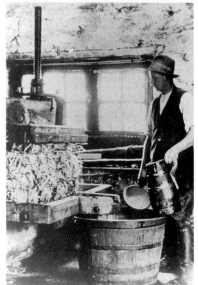

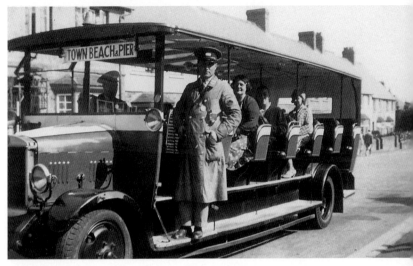

The little 'toast rack' run by the Western National in the 1930s from Alcombe to the sea front was very popular.

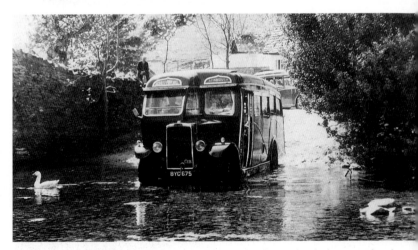

Nine local bus companies, perhaps ten, some of them with only a single vehicle, operated in the neighbourhood: (Western) National, Royal Blue, Scarlet Pimpernel (which still run), Dunn's Coaches, Lavender Blue, Red Deer, Relion, New Imperial and Mascot Buses. Here a Scarlet Pimpernel coach, first registered in the mid-1930s, splashes through Badgworthy Water at Malmsmead from Devon, on the far bank, into Somerset.

Three

Villages of the Coastland

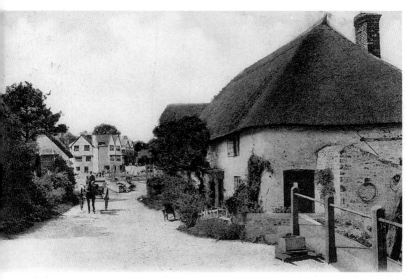

Porlock Weir, showing the cottage home of the Rawle family on the right, 1880s. The land beyond has been raised and made into a car park.

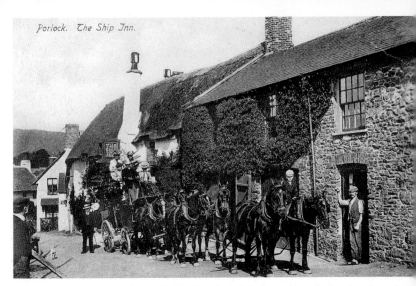

The Lynton coach pauses to bait at the Ship Inn, Porlock, before tackling the 1-in-4 gradient of Porlock Hill.

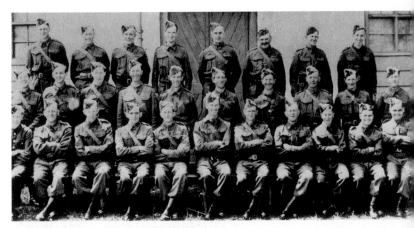

Porlock Home Guard outside Holnicote Stables, 1942. Back row, left to right: Arthur Kingdon, Ted Rowlands, Jack Gould, Philip Moore, Harry Prescott, Albert Stark, Arthur Moore, Wally Harding. Middle row: George Davis, Reg Tame, Stafford Mills, Dick Creech, Eddie Keal, Bob Williams, Tom Farmer, Bill Tate, Leonard Bennet, Jack Farmer. Front row: Mervyn Arscott, Ernie Bellamy, Sid Webber, Bill Gunter, Jack Kingdon, Tom Rawle, Jack Crockford, Tommy Hill, Tony Hale, Percy Sedman, Clifford Choke.

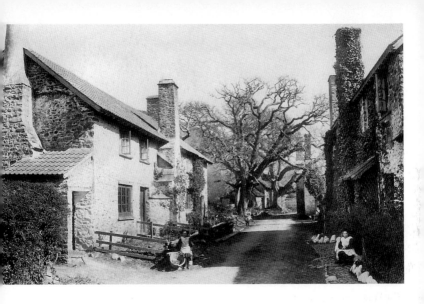

Above: Bossington, seen here c. 1900, was so long famous for its great walnut trees that the loss of even one in the 1960s seemed to some like the death of an aged friend. Photographs of a few years earlier show the cottage on the left as thatched. From the look of the little girl with the clothes flask, it is Monday, wash day.

Right: Outside one of the cottages on Selworthy Green, 1907.

39

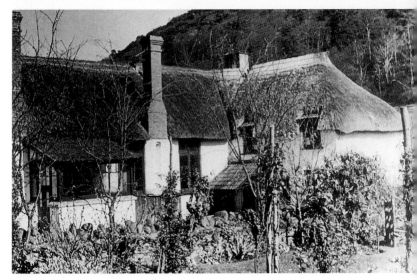

Old Allerford school closed in the 1980s for lack of pupils, but was saved for the community and converted to a museum of rural life with a reconstructed schoolroom It is well worth anyone's visit.

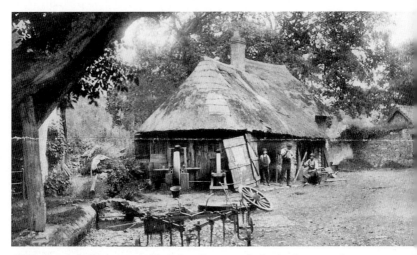

Allerford smithy, 1907, was worked by Robert Kent, one of a family of repute in the neighbourhood for over 200 years.

Alcombe, the Cross Farm, *c*.1905. Alcombe was once completely separate from Minehead, and remained contentedly so until the 1930s.

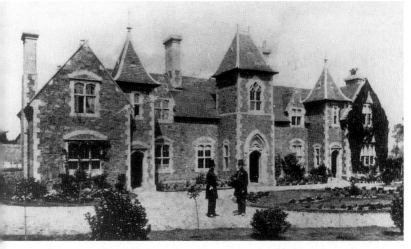

Dunster Police Station was erected in 1858, with living accommodation for a superintendent and a sergeant, and a court house. The plants are well established but the police are wearing the old uniform, so presumably this was taken in the late 1860s. Sergeant Ashman (left), addressing a respectful constable, was so punctual on his beat that the Carhampton blacksmith, James Watts, said that he could set his watch to the minute when the sergeant came by. The handsome lawn and ornamental flower-bed have long since fallen victim to the car.

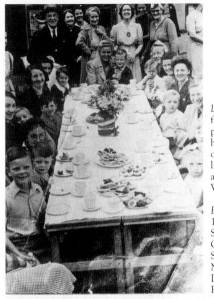

Left: VE Day tea for Dunster children in front of the village hall, May 1945. In the previous few months the people of Dunster had collected over £1,000 to help the people of Elst in the Netherlands, which had been liberated by troops of the Wessex Division among whom were two Dunster men, William Dainton and Wesley Gould.

Below: Dunster Home Guard on Castle Hill, 1943. Back row: Ossie Gould, Gerald Sully, Stan Ladd, Bert Davey, Jim Copp, Chris Champion. Middle row: Reg Vaulter, Roy Sully, Jack Jones, Charlie Welsh, George Needs, Fred Hunt. Front row: Harold Gill, Don Vaulter, Cliff Rowe, Tom Winter, Ken Radford, Mr White.

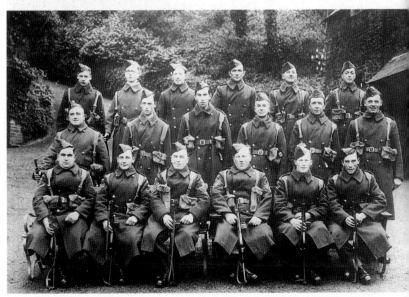

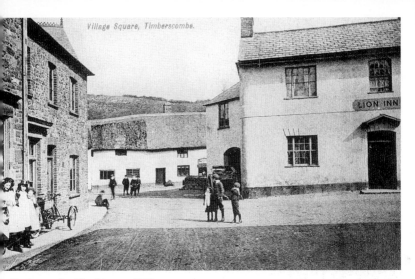

Timberscombe, The Square, c.1905.

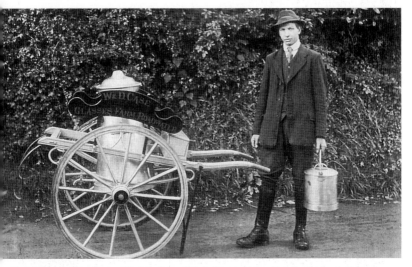

Fred Inkerman Bond's son, Fred Andrews Bond, dairyman as well as much else, is delivering milk around Timberscombe, c.1910. This was long before governments forced us all into pint-sized standardization, and with his copper or aluminium measures Frank would serve you a half-pint, pint or quart of the freshest milk out of his churn, often with a spoonful over.

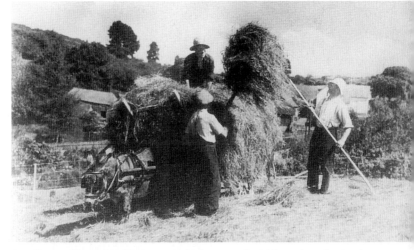

As well as a milk round to deliver, a post office to run and a fiddle to play in local orchestras, Fred had a smallholding near Timberscombe, where he is seen haymaking, c.1930.

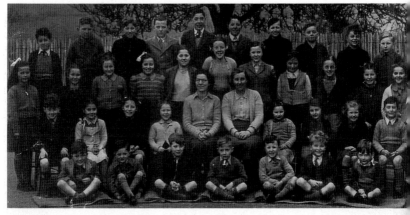

Timberscombe School, 1949. Back row, left to right: Christopher Boycott, Gordon Elford, John Nicholls, Dennis Land, Archie Dyer, David Brooks, Basil Slade, -?-, John d'Allasio, Winston Land. Third row, standing: Josephine Slade, Judith Perkins, Susanne Doors, Chrissie Brooks, Freda Dyer, Mary Pigeon, -?-, Wendy Badcock, Phyllis Quick, Jennifer Bond, Pam Bircham. Second row, seated: Alan Boycott, Betty Dyer, Carol Golden, Judith Doors, Mrs Willis (Head), Mrs Gillard (Infant teacher), Georgina 'Bubbles' Elford, Vera Jury, Margaret Perkins, Tony Gibbons. Front row, seated: George Parsons, Martin Jury, Michael Hooper, Billy Millard, Nigel Partridge, Derek Poole, ? Badcock.

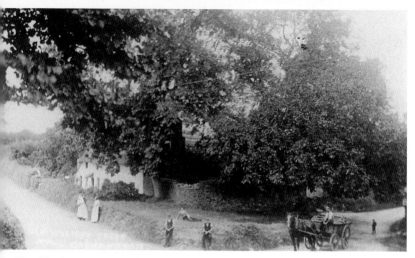

The old walnut tree, 1900, so long Carhampton's pride and joy.

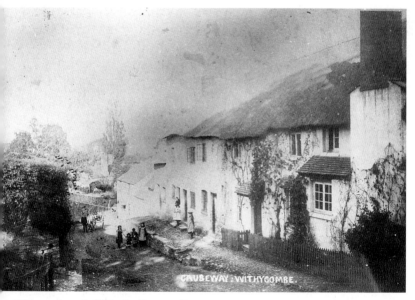

Withycombe, early 1900s, the Causey or Causeway.

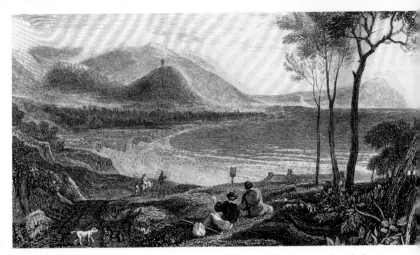

The companion piece to Turner's well-known view of Watchet. The foreground, with the chimneys of the Blue Anchor Inn, has changed little, but the distant low-lying ground has lost most of the trees which gave it the name of Marshwood. In the middle distance the coast road from Watchet to Minehead, seen here on the left, leads down and across the bay just above high water mark. It was once more important locally than it is now, and Coleridge and Wordsworth walked it on the famous journey to Lynton in November 1797 when they planned the 'Rime of the Ancient Mariner.'

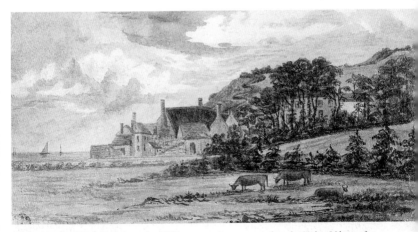

The east end of Blue Anchor in the 1850s, as seen in a water colour by Helen Vibart of nearby Chapel Cleeve. She was orphaned when her parents were murdered in the Massacre of Cawnpore in 1857.

Four

Washford, Old Cleeve and Bilbrook

Lower Washford, c.1900, showing Huish Lane, with the school house on the left, the old chapel cottage ahead and Huish and Osborne Cottages on the right.

Left: Cobblers Steps, Washford, leading to the Monks' Path which connected Cleeve Abbey with the church at Old Cleeve. The steps were once thought to have been built at the same time as the Path, but more probably they date back only to 1874, when the Great Western Railway Company made massive changes in ground levels here while extending the line from Watchet to Minehead. The girl at the top is Jenny Bryant; the boy and the older girl have still to be identified.

Below: Old cottages, Lower Washford, next to the school playground. Formerly the homes of the Stevens and Bailey families, these were demolished in the early 1970s. This photograph was taken on the day demolition began; one chimney has already gone.

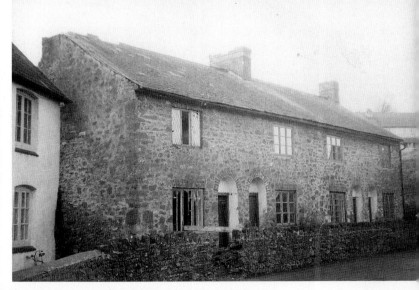

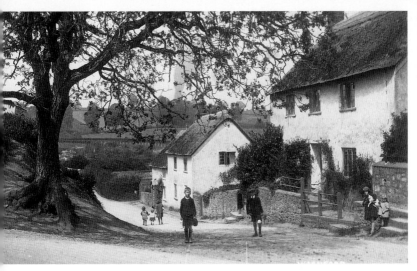

The old walnut or French nut tree has stood here for many generations and given its name to this corner. Despite hard wear and much discouragement it still survives.

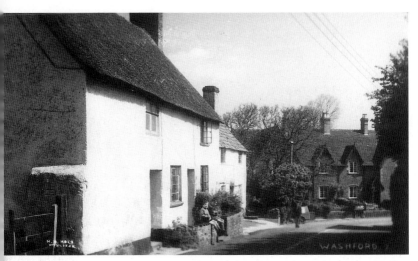

Jasmine Cottage, the Wheatsheaf Inn and Albert Terrace in the 1950s, little changed today except for the 10,000 cars a day pounding through! Who would believe that some people do not want a bypass?

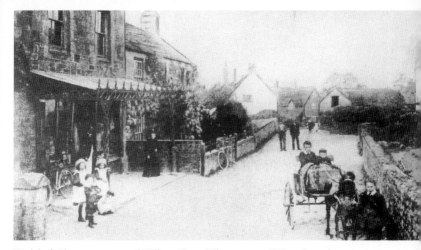

Washford. The grocery store of William Henry Whittington, c.1910, with its charming cast iron veranda, ornamental woven pillars and (apparently) Virginia creeper. Little remains of this pleasant attractiveness now that 10,000 cars and lorries a day thunder past.

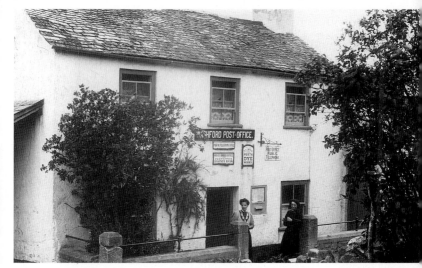

Washford. A few steps down the road from the grocers, this cottage was the post office, run by James Bellamy, father and son, for more than half a century from 1850 onward. The ladies are Mary Bellamy (left) and Ada Palser who, as Mrs Court, became the postmistress across the road and ran the new office from 1920 to 1967.

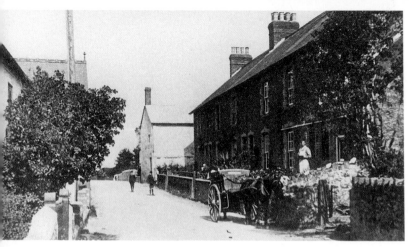

William Shepherd's butchers shop, showing his trap about to be loaded up for delivery, c.1910.

These cottages, built of stone from the dissolved Cleeve Abbey, probably in the seventeenth century, stood at the top of the Ramp until the mid-1930s. Although below the level of the road when this photograph was taken, its level had risen so much that an old lady living in them could remember how as a child she would look down on the carriages passing by.

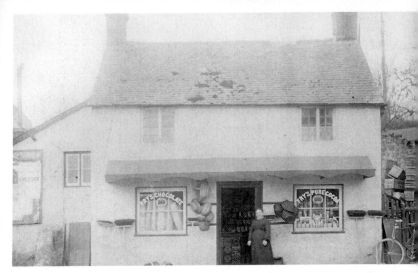

Ellen and Albert Shepherd's grocery stores, Washford, *c.*1900, with piled biscuit tins and enamelled lettering on the panes. The shop offered, among much else, Shepherd's Toothache Powder and Embrocation or Family Friend, and advertised in Kelly's Directory. It was kept open till 11 p.m. on Saturdays for the sake of one customer.

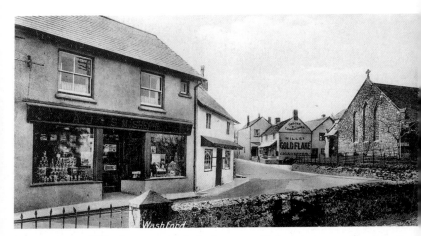

Forty years later, *c.*1936, a large extension for hardware was added, producing a startling contrast of the new plate glass windows and the old six-inch panes – but they kept the old lettering. Clearly the planning system had not got into its stride when the Gold Flake notice was painted on the side wall of Tom Burnett's grocery shop!

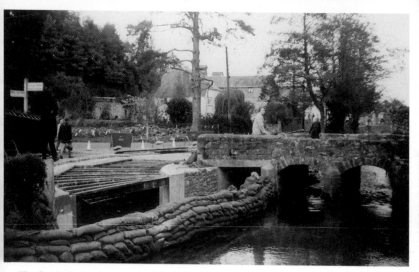

The flood relief works constructed at the gate of Cleeve Abbey in about 1970 are sadly out of keeping with the native Somerset style of bridging, but they have undoubtedly saved the village from miserable experiences since their completion.

Dragon House, built in 1712 by the brothers Harris reputedly from the proceeds of smuggling, has had a varied history as, successively, a private residence, an inn, the Green Dragon, a Methodist class meeting and preaching house in the ownership of the Symons family for 100 years, and from 1900 to 1950 as a private residence, as seen here, again. An hotel since about 1950, it enjoys an enviable reputation.

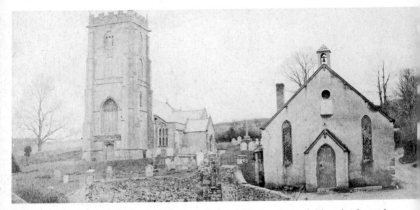

Old Cleeve church, probably in the 1860s, since when much has changed. The schoolroom has lost its pretty little bell turret, a lych gate was added in 1907, and a yew has grown on the left of the path, obscuring but perfectly preserving William Oatway's 1840 tombstone from the erosion and decay seen in all others of that time.

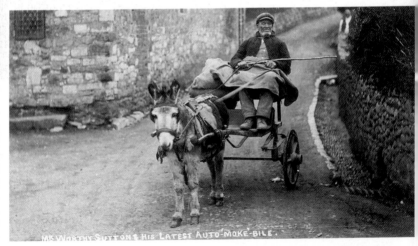

MR. WORTHY SUTTON & HIS LATEST AUTO 'MOKE' BILE.

Worthington Sutton, generally known as Worthy, was John Slade's predecessor at Warren (see p. 76) in around 1900, and travelled to and from his home in Bilbrook on a cart pulled by one of his three donkeys, Jacker, Jimbo or Traveller (seen here). (Some wag, not unexpectedly, dubbed it 'Worthy's automo(ke)bile'.) Worthy's face, scorched and reddened by the heat and fumes of the kiln, belied his kind and gentle nature. One of the first to join the Salvation Army hereabout, he worked long, hard hours six days a week, but on the seventh, instead of taking his ease, he travelled around on foot, visiting and cheering whoever he had heard was needing help. Here he is seen driving down past Trowbridge House.

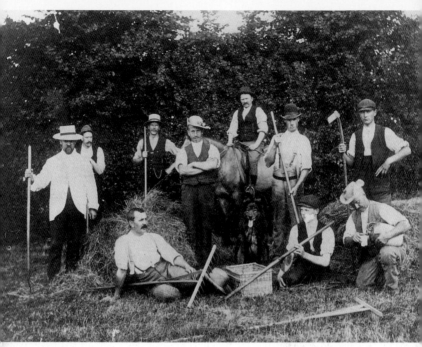

A group of haymakers in butcher William Shepherd's field take a welcome – and probably unexpected – break. They are, standing, left to right: William Shepherd, Silas Locke (postman), Jim Ridgway, Bob Lewis, Walter Slade (on horseback), Harry Chidgey, Bob Milton. Seated: Albert Shepherd, ? Crews, Jimmy Edwards.

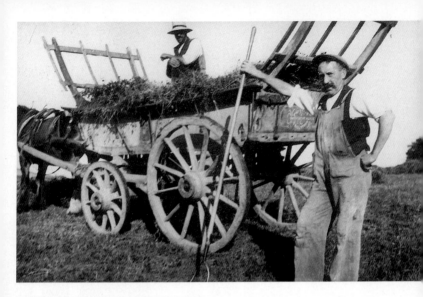

Above: William Davey, uncharacteristically resting on a 'prong' instead of wielding one, takes a minute off from loading the hay wagon.

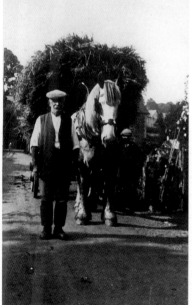

Left: Wilfred Chamberlain was a terror to apple-scrumpers and wayward boys but devoted to the horses he worked with. Here they are in the 1930s, bringing home a load of hay.

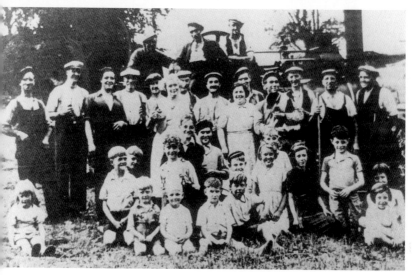

Haymaking at Washford, c.1936. The group includes Pam Cridland, Victor Gould, George Bailey, Dick Stevens, Mr Stevens, Arthur Stevens, Bill Cridland, Mr Beaver, Cyril Bryant, Bill Upham, Irma Cridland, Geoff Cridland, Victor Cridland, Malcolm Cridland, Toby Bryant, Jack Cridland, Bill Hole.

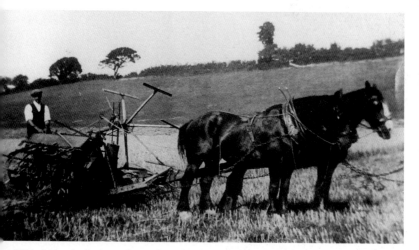

Wilfred Chamberlain's son Percy riding a binder at Abbey Farm, c.1935.

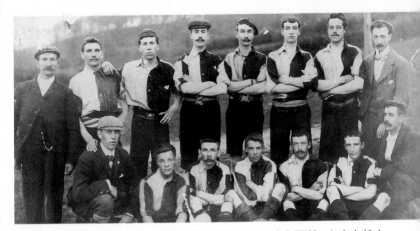

Washford Football Club, c.1920. Back row: W. Sully (Committee), P. Webber (right half), J. Lovell (left back), E.A. Lovell (goal), Sam Taylor (right back), J.J. Hole (centre half), J. Babbage (left half), Percy Chubb (Committee). Front row: Howard Shepherd (linesman), W. Sully (right forward), H. Stevens (inside right), -?-, C. Tame (left forward), Charlie Stevens (Committee). (C. Stevens also appears in the photo of the Watchet foundry on p.75.)

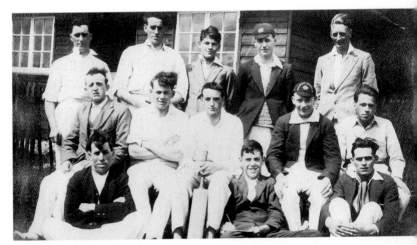

Washford Cricket Club, 1925-1930. Back row, left to right: Lionel Carpenter (postman), Ray Davis, Arthur Burnett, Hedley Taylor, Leslie Jenkins (Railway Hotel). Middle row: Frank Lock (postman), Herbert Burnett, Reg Davis, Ted Burnett, H. Stevens. Front row: Walter Davey, Ronald Bates, George Burnett.

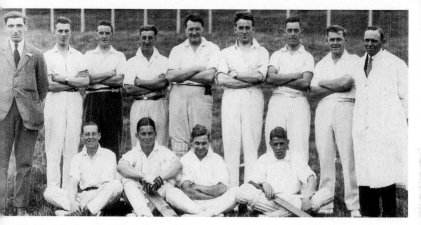

Washford Cricket XI, 1930. Back row, left to right: Charles Chilcott (Shells) (Secretary), Maurice Brewer, Reg Davis, Harry Burnett, Harry Connolly, Roy Davis, Ronald Bates, Herbert Burnett, Bill Upham. Front row: Jim Edwards, Basil Bates, Ted Burnett, Leslie Blanchard. (Herbert Burnett and Jim Edwards were killed in the war, Herbert in a bomb disposal squad of the Royal Engineers and Jim in the RAF.) Those – cricket-wise at least – were the days! The sporting talent of this village of a few hundred people needed more outlet than this one team, and 'friendlies' would be played between teams captained by Basil Bates and Reg Davis. Can one imagine that in any village now?

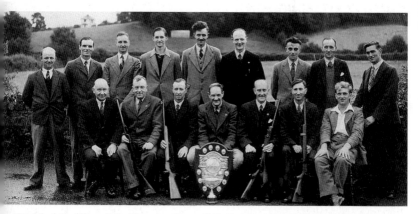

Washford Small Bore Rifle Champion Team, 1940. Back row: Percy Webber, Wilfred Burnett, Arthur Milton, ? Lakeman (Torre), -?-, Frank Noyes (Pranketts), Tom Moggridge, John Hepper (Hungerford), Harvey Sykes (Dragon House), Austin Burnell. Front row: John Wood, Wm Howell, Howard Shepherd, Col. Hutchinson (Capt. New Mills), Claude Gooding, George Shepherd, Keith Burnell. The club met for practice in an abandoned quarry by the foot bridge over the mineral line at Torre. They shot across the line, but no one was ever injured as a result.

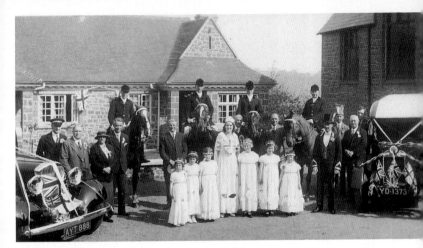

Washford and Old Cleeve celebrate King George V's Jubilee, May 1935. May Queen Mary Houlden poses charmingly with her princesses. Left to right: Joan Pincher, Verna Chamberlain, Jean Smith, Marjorie Eaton, Elizabeth Wood, Pat Cridland. Around her stand, left to right: Syd Pinchen (chauffeur to G.S. Lysaght), W.G. Court, Miss Palmer (Schoolmistress), Robert Eaton, Charles Burnett (returned from Chicago). Mr Boon (station-master), Frank Burnett, Howard Shepherd, George Shepherd, Arnold Fleetwood and William Howell (British Legion). The horsemen are, left to right: ? Welsher (groom to G. Hosegood), Geoffrey Leversha, Comer White and John Wood.

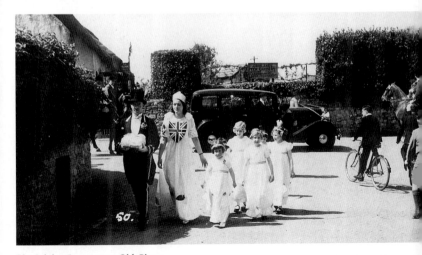

The Jubilee Queen visits Old Cleeve.

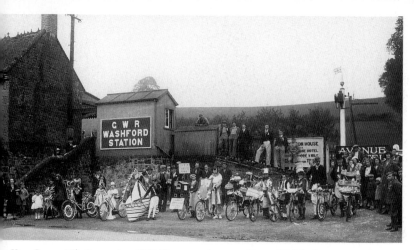

King George VI's Coronation, 1937. The procession assembles at Washford station. At the foot of the steps is Mr Pike (station-master) and at the rear on the left is Howard Shepherd. Behind the boat, left to right, are W.G. Court, Frank Burnett, A.B. Fleetwood. In the centre with the cycle is Margaret Burnett, and on the right with cycle and Union Jack waistcoat is Tom Burnett.

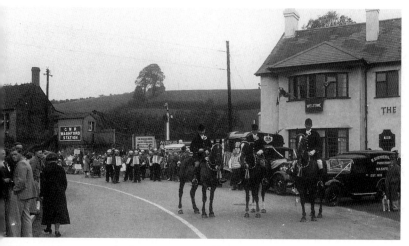

The procession steps out for the recreation ground led by an accordion band.

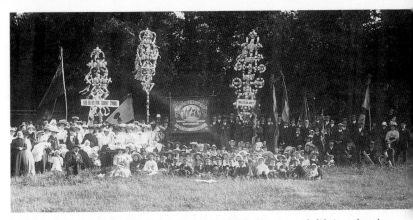

Washford Wesleyan Sunday School Festival, 24 July 1908 – all ages provided for! pupil-teacher ratio excellent! An unimaginable amount of work and pride must have gone to the making of the floral and decorative standards which are much in the tradition of the local friendly societies. The bright banner forming the centre-piece seems to be new for the occasion, but...

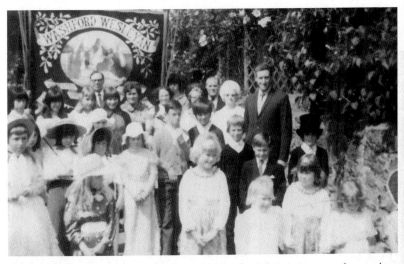

... it still looked bright enough when displayed at the School's 150th Anniversary sixty-five years later. Assembled in Lower Washford are, very back row, left to right: Bryan How, Colin Chilcott, Norman Hudson, Donald Tapp, Rodney Ettery. Back row: Mandy Baker, Janet Towells, Philippa Court, Julie Redd, Jean How, Freda Burnett, Marion Chilcott, Gwen Ettery, Adrian Cridland. Front row: Angela Cridland, Linda Redd, Dawn (?) Lile, -?-, -?-, John Baker, Neil Cridland, -?-, -?-, Paul Burnett (?). Very front, left: Janice Cridland. The four girls at the right have not been identified.

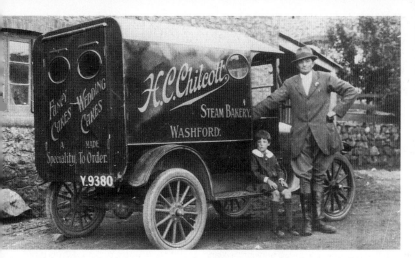

Harry Chilcott, Washford baker, with son Colin (1914-1976), probably photographed in October 1920 when he registered his new Ford van, described somewhat surprisingly as 20 hp, 14 cwt and painted a chocolate colour. Colin later followed his father's trade, led a three-piece dance band, served in the Reconnaissance Corps in France in the Second World War, and became a chapel organist.

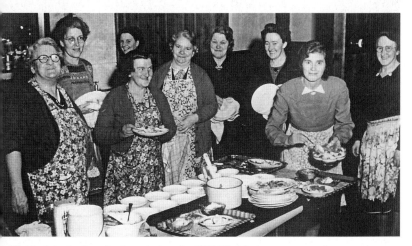

Washford. In the days of strict rationing after 1945, Washford gave a warm welcome to the Rabbit and Hot Potato Suppers in the Methodist Schoolroom prepared by, left to right: Mrs W. Bryant, Ena Stevens (Martin), Marion Swanger, Vera Chilcott, Mrs Applin, Mrs Tapp, Ida Shepherd, Mrs Doris Coverley, Gertie Shepherd.

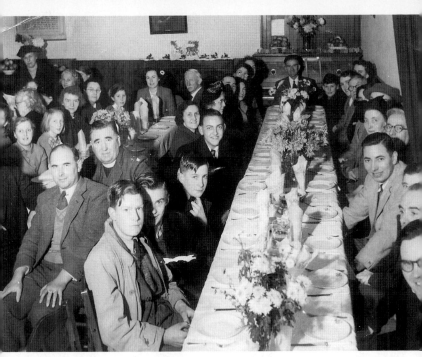

Harvest supper in the Methodist Schoolroom, 1952. Right-hand table, right-hand side, front to back: Percy Allen, Ted Stevens, -?-, Gordon Allen, Victor and Nora Stevens, Mrs Burnett of Abbey Farm, Freda Burnett, John Farthing, Ena Howe, Victor Webber and Marion Chilcott. Bert Hole is at the top. To his right are Mrs Bert Hole, Mrs Vince Webber, Cicely and George Shepherd, Mildred Bowyer (née Shepherd), Mrs Hayes of Station Road, Edward Gould, Bob Croucher, John Lillington and Ivor Sully. Middle table, front to back: Jack Fleetwood, Revd Gourlay Thomas and William Gard of May Terrace. Mrs Rae Hudson is at the top, and to her right are Elizabeth Burnett, Mrs Burnett (Croft), Mrs Bryant of Quantock Cottage and Janet Bryant, Margaret Sully and, largely hidden, Arnold B. Fleetwood. Mrs Webber of Abbey Road is at the top of the left-hand table, and to her left are Mrs Beaver, Mrs Cridland of Verden Terrace, -?- and -?-.

Watchet
The Town

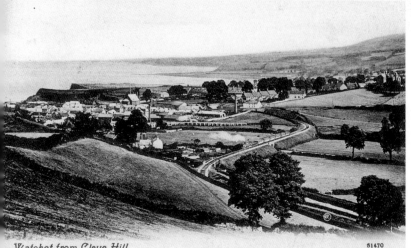

Watchet from Cleve Hill

51470

Watchet from Cleeve Hill, c.1900. Clearly shown are the raised GWR with the 'Minehead Flyer', and (centre) the aqueduct supplying Stoate's mill in Anchor Street.

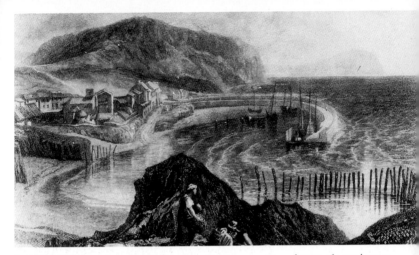

In 1821 J.M.W. Turner travelled the country to paint a commissioned series of coastal scenes. For this area he chose Watchet (seen here) and Cleeve or Blue Anchor Bay. He is renowned for his devotion to the rendering of atmosphere and light rather than attention to minuteness of detail, but nevertheless this picture seems an accurate general record of the scene as it was until the 1850s, when the Ebbw Vale (Iron Ore) Company built the harbour south wall, filling in behind to make the Esplanade.

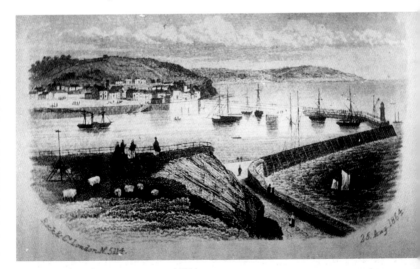

Watchet Harbour from an engraving of 1864.

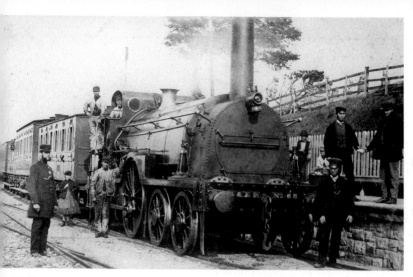

Watchet station (terminus) on the Bristol & Exeter Railway in the late 1860s. The picture is worth studying for its detail: the broad gauge loco, carriage lamp, railway uniforms, and the dress of the people on the platform.

The Market House from the east in the early 1900s, when it was Luke Organ's ironmongery shop. In 1978 it became the Town Museum. It is open all the year round and should not be missed. The small annexe was once the town lock-up.

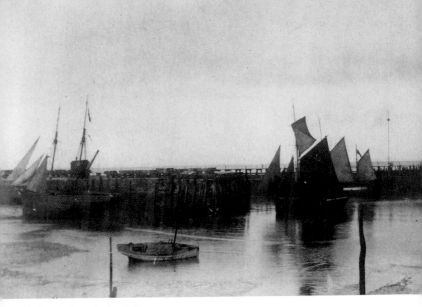

Watchet Harbour in the 1860s.

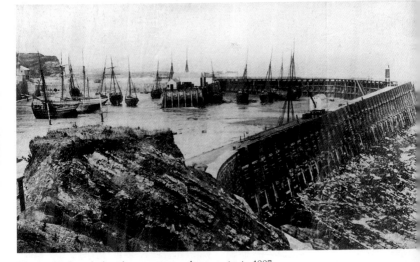

Watchet Harbour before the extension to the west pier in 1887.

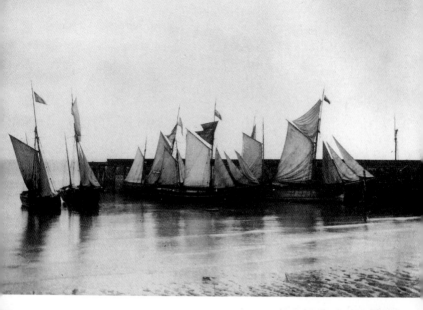

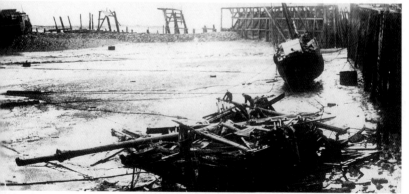

The twentieth century opened, prophetically, with storms, and that of 28 December 1901 wrecked Watchet harbour. This photograph, taken the morning after, shows the west jetty of timber shattered by the violence of the waves which crashed through, tearing vessels from their moorings and smashing them against the east wall. The jetty was rebuilt as a stone breakwater and the harbour became a safe anchorage, but as the tides could no longer scour the harbour it became silted up and the deep mud has been a problem ever since. Nowadays a channel can be cleared by high-pressure hoses, but formerly the work was done by teams of men, sometimes in such atrocious conditions that ice would form on the handles of their shovels as they dug.

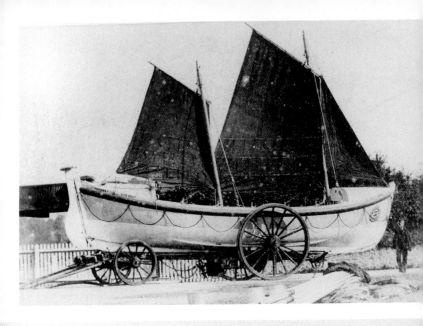

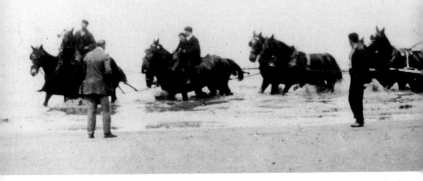

In about 1920, whether because of the state of the tide or in emulation of the Great Overland Launch of the Lynmouth lifeboat many years before, Watchet decided to launch the *Sarah Pilkington* from Blue Anchor.

Opposite above: Watchet had its own lifeboats from 1875 to 1950, and the lifeboat house built for it in the first year is still in use, but as the town library. The first boat, named the *Sir Joseph Scones*, was brought by rail from London, unloaded from the train at Williton (as shown here) and then hauled by road to Watchet, no doubt to give the neighbourhood due notice that Watchet was well and truly one up!

Right: Hauling the lifeboat up Cleeve Hill. Alfred Gardner is leading the near side horse.

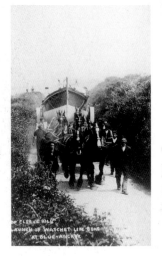

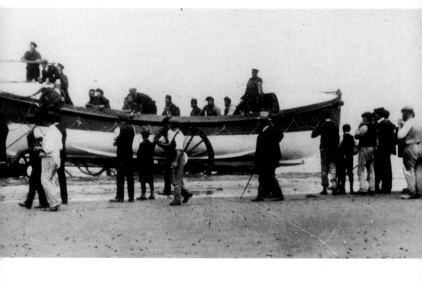

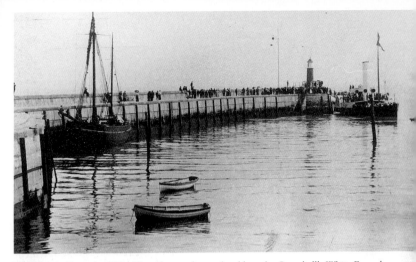

West Pier in the early 1900s. The tide must be on the ebb as the Campbell's White Funnel steamer is taking passengers on to the upper deck. Given the speed of the ebb it cannot afford to wait around.

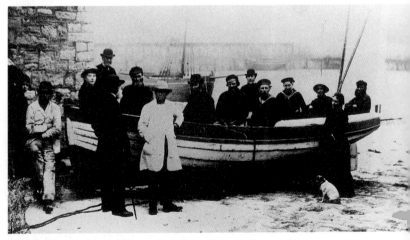

Hobblers and their boat, 1880s. Three boats and crews like this would race one another, rowing like fury to be first to an incoming ship and to help pilot and warp her into harbour, for which work they were paid hobble money. It was little enough reward when divided by six, but in those days every penny counted. The hobblers' ways of working and their subterfuges are vividly described in Ben Norman's *Tales of Watchet Harbour*.

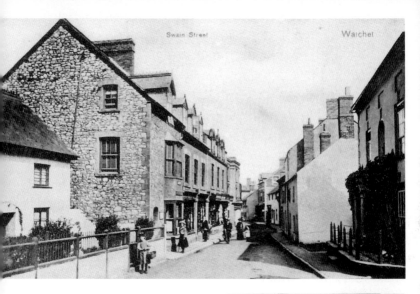

Above: Looking down Swain Street, *c.*1910. The name, reminiscent of King Sweyn, father of Canute, is not the only evidence that Watchet in Anglo-Saxon days had a Danish element in the population and may have been a Danish trading-post.

Right: A group outside J.H. Walker's barber shop in Swain Street, with Joe Colwell in the white apron. Known as 'Fearless Joe', he earned his nickname when he accepted a lion-tamer's challenge to shave him in the lions' cage. He went through the ordeal looking distinctly nervous but emerging unscathed, and, challenging the showman's reluctance to pay up, got his £5 reward. More importantly, he made himself a name. Later he set up shop on his own account across the street. The broom and notice tied to the barber's pole were part of a West Country pleasantry played on men whose wives were away. The notice reads, 'Apply by letter only: Hello girls, now's your chance, Another vacancy. Lovable housekeeper wanted, must be fond of kids and cats, mend gamps and lather customers.'

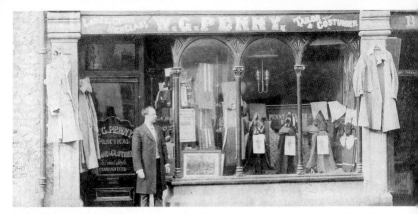

Although Watchet was attacked and burnt by the Vikings in 997, unlike Minehead its character has not so far been ravaged by the modern barbarians of commerce and the 'corporate image'. Nearly all the businesses in Swain Street and Market Street are happily still in private hands, and most of the shop-fronts retain the quiet seemliness of Edwardian days. Mr W.G. Penny, bespoke tailor of Swain Street and Urban District Council Chairman, would certainly have approved. As a devotee of cricket and owner of one of the first wireless sets in Watchet, he would regularly post the Test Match scores on a board outside his shop.

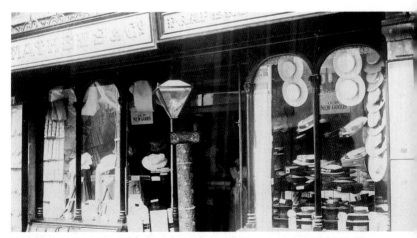

Mathews & Co.'s, Drapers and Outfitters, near W.G. Penny's, 1905. There are straw boaters in the window (all the rage at the moment!) and gas lighting over the door – and note the pretty ironwork frieze above the shop-front. Shopkeepers undertook lengthy journeys for custom. The back of this card, sent to a customer in Luxborough eight miles away, reads, 'Mr Mathews will call on you Friday next week with full range of Autumn goods when your esteemed order will oblige.'

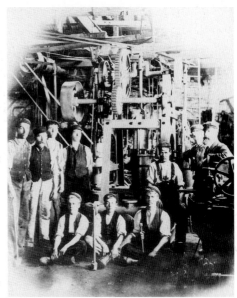

Swain Street Foundry, c.1910. The firm established by John Gliddon in 1833 and still operating in West Somerset and North Devon ran this foundry from 1875 to 1946 and fulfilled orders both for home and away. Here the staff are making a triple cylinder expansion engine for a paper mill in Cheddar. At the far right stands Sam Blackwell, foreman and, in an emergency, dental surgeon with the aid of a pair of engineer's pliers. On the far left is Charlie Stevens, a noted cyclist who won all the August Bank Holiday races on the recreation ground. (He also appears on p. 58.) The title FOUNDRY is still visible outside the building. In behind the foundry was another one reached by a passage from Market Street and run by Charlie Hole.

The Strong family outside their home in Anchor Street, a good place for sea food, with cockles by the half-pint and none of the mumbo-jumbo of metrication.

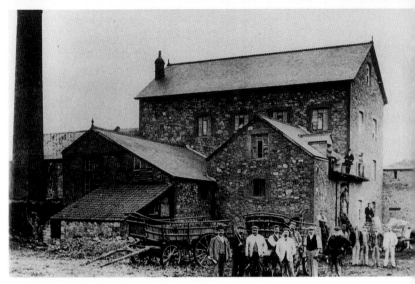

Staff of Stoate's flour mill in Anchor Street, c.1910, shortly before it was engulfed by fire.

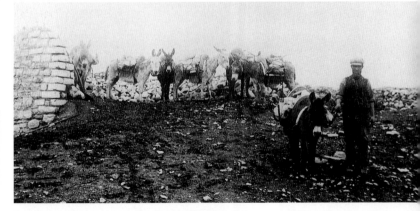

For centuries the boulders on the shore at Watchet were burnt to yield lime. Sure-footed little donkeys such as these carried the stone up a steep path in the crumbling cliff face to kilns at the top. The product was highly esteemed: not only did it make some of the strongest cement in the kingdom (Winstanley used it for the Eddystone lighthouse), it was also used in large quantities to sweeten the acid soil on the hills, and farmers would bring their carts a day's journey for a load. John Slade (shown here) was the last of the lime burners at Daw's Castle, near Watchet. Production ceased with the Second World War and was never resumed.

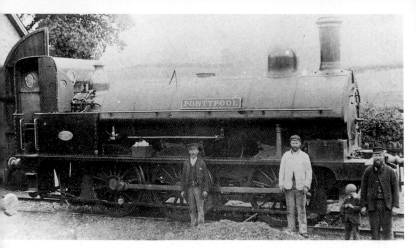

West Somerset Mineral Railway. The *Pontypool*, *c*.1890, with crew, left to right: Joe Duddridge (guard), Nicholas Redd (driver), James Wood (fireman) and his son Edmund. Even today Joe Duddridge's shout of 'Right away, Nicol!' has not quite died out in Watchet.

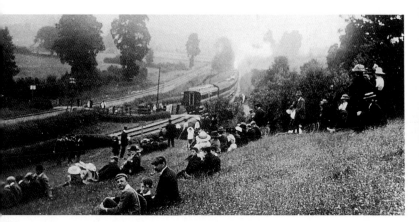

In 1912 an Australian company, Angus & Co., hired a stretch of the old mineral railway at Kentsford to carry out an experiment with automatic braking, and crowds from Watchet and around came to see what would come of it. The two locomotives were put in place about a mile apart, and at a given signal the drivers set them in motion then jumped off. The system worked perfectly and the locomotives pulled up a hundred yards apart, to the boundless satisfaction of the engineers and, no doubt, the disappointment of a few fellows hoping for something even more spectacular.

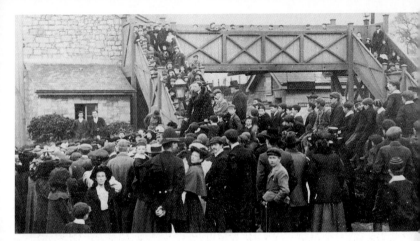

A scene from the great election of 1906, which probably aroused more interest and passion than any before or since, and remains a lifelong memory for all who took part in it. Here the Liberal candidate, Dudley Ward, is addressing a large crowd from the steps over the main line railway.

W.G. Penny, the tailor appearing on p.74, was a member of the Somerset County Cricket Club and an enthusiastic organiser. Every year throughout the 1930s he arranged a friendly between the County XI and his own boys which allowed the latter, including Harold Gimblett and Alan Pearse, to see the standard they would have to measure up to if selected for the county, and also gave local lads the chance to see their heroes, such as Arthur Wellard and Bill Andrews, close at hand.

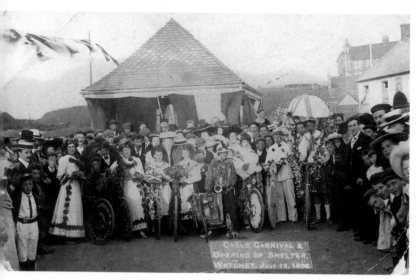

Cycle Carnival and Opening of the Shelter on the Esplanade, July 1906 – and some very fetching cyclists too! The shelter had been erected by the Sports Committee led by Will Lee, who also raised money for the safety railings along the harbour.

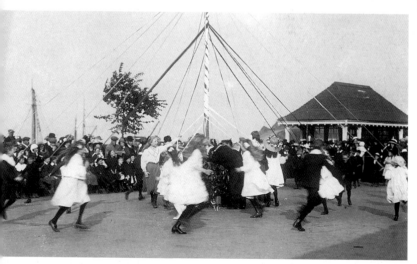

Maypole dance a year or two after the above.

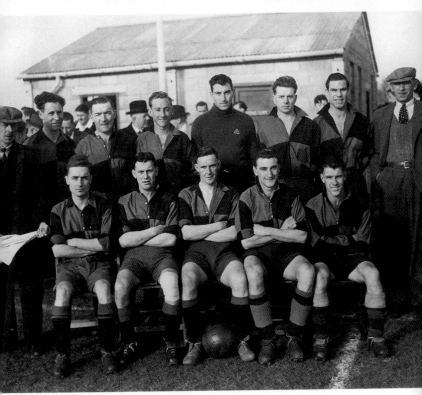

Watchet Town AFC, 1948-49. Back row, left to right: Albert Strong, Owen Baker, George Alexander, Alec Mayo, Gerald Bellamy, Dennis Williams, Desmond Chubb. Front row: Leslie Stevens, Dennis Pugsley, Stan Terry (RAF), Joe Taylor, Alfred Edwards.

Six

Williton

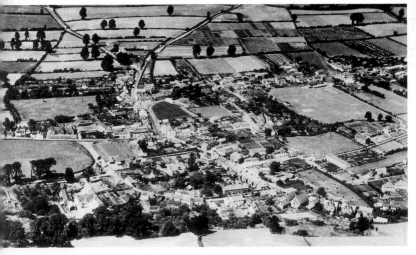

Aerial view of Williton, 1930s, with no building beyond the Masons Arms or north of Long Street.

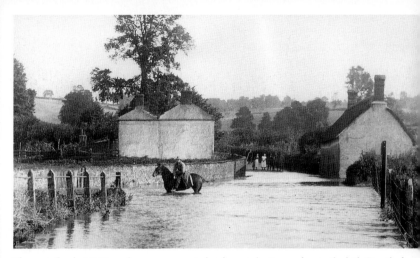

The great flood of 1924 was by no means an isolated event, for time and again the little Doniford Brook (or River Swill or Willet) has overflowed its banks at Williton and (here) at Highbridge. Mr Moorman of Egrove Farm, here negotiating the flood on horseback, farmed in Australia and always wore his bush hat after, maybe as a reminder of pioneering days in a far-off land.

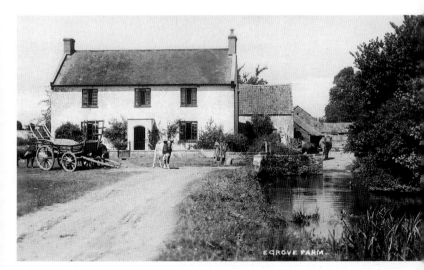

Egrove Farm, c.1920.

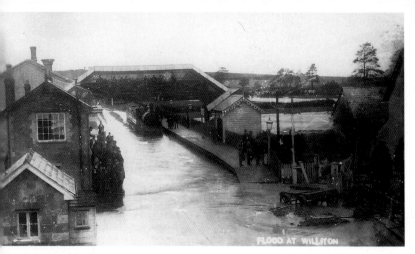

Exactly fifty years before, in 1874, the stream flooded Williton station. The permanent way was still Brunel's broad gauge, which remained until October 1882, when the whole GWR system was changed to standard gauge between a Saturday night and Monday morning.

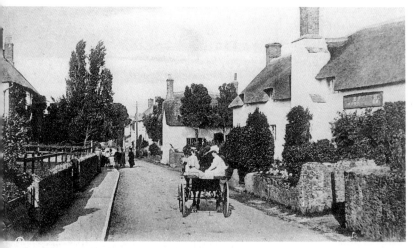

Long Street in Edwardian days, when it enjoyed the popular name of Laburnum Avenue. Ah, what a change...!

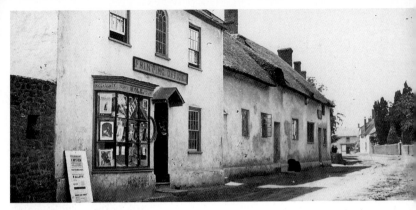

The earliest photograph of Hole's studio, 1870. The family practised photography for three generations and a hundred years from 1856 until the last Hole, Henry, retired in 1974. Printing and photography went well together and complemented each other; in the early days one on its own would hardly have provided a living. Once well established, the firm had studios in Minehead and Watchet as well as here, in Long Street, Williton.

The Hole family's celebration of Queen Victoria's Jubilee in 1887 may have raised an eyebrow or two, but the meaning of the banner was explained as 'May she be hung with diamonds, drawn in carriages and quartered in palaces.'

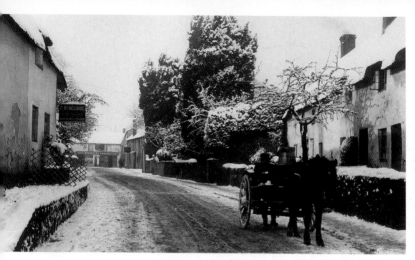

Long Street under the snow, April Fool's Day 1922. There has been traffic about, but not enough for it to have to keep to the side of the road. Herbert Hole's house and studio are on the left. He had only to step out to take this photograph. Though he might not have seen much of the milkman behind that cap and beard, he would have heard him. William came over from Watchet and everyone knew when he was on the way: he controlled his horse with scraps of hymn tunes interspersed with bad language.

In Long Street two years later. Little Henry Hole and his mother and sister look with concern at the torrent rushing out of Bob Lane and past their cottage door.

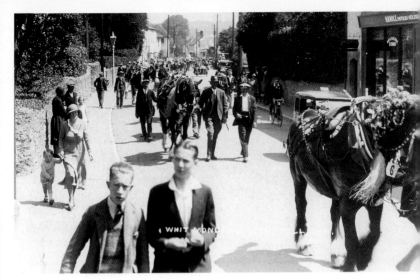

Whit Monday, now – alas! – abolished, like so many good things in our heritage, by Whitehall, was always Williton's great fete and show day. The procession up Long Street from the recreation ground is headed by Arthur Stoate leading his prize-winning horse, and behind them comes Percy Chamberlain of Washford, who lived for his horses. The lad at the front on the left is Larry Bullen; others are not yet identified.

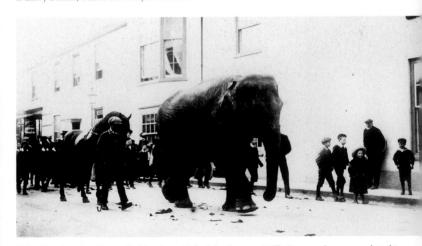

Whit Monday was also marked by the arrival of the Bertram Mills Circus, who put up their big top in a field near the station and performed in the evening.

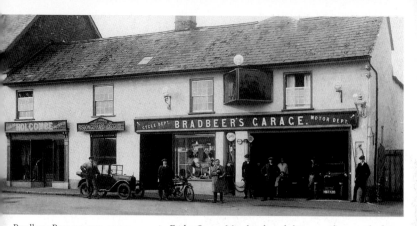

Bradbeer Bros ran two garages, one in Friday Street, Minehead, and this one, photographed in the 1920s but remaining for another forty years. The petrol pumps were hand-cranked, a slow business needing three rotations of the crank or eighteen strokes of the handle to deliver half a gallon, as the author can vouch from experience. To pump a tankful was hard work indeed, but in those days local drivers rarely bought more than two or three gallons at a time, even at 1s 6d a gallon. Standing outside are, left to right: Ted Applin, Carol Lyddon, Stan Bradbeer, Sid Peppin (mechanic), Jack Rolling, Mrs Bradbeer, Arthur Holcombe, Ted Ashman.

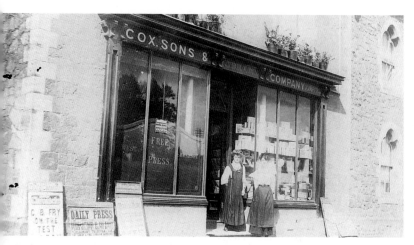

Cox's Stationers and Newsagents, near the Post Office, 1901. The shop stood on the corner of the drangway leading to the old chapel (later the Girls' Friendly Society hall). Although greatly altered in appearance, it still sells stationery and newspapers. The young lady assistant on the right is Eva Hill of Minehead, sister of Murray Hill (see p.31) and, later, manageress of the Minehead branch (see p.20).

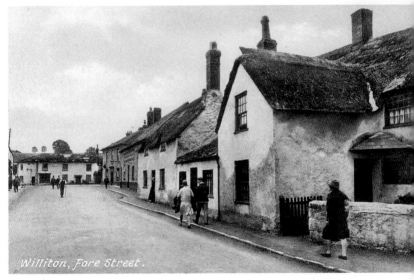

Fore Street, looking toward Bellamy's Corner.

Parsons & Hann's, *c.*1920, groceries and household goods, drapery and men's outfitting. One didn't need to be especially trustful to display one's goods on the pavement.

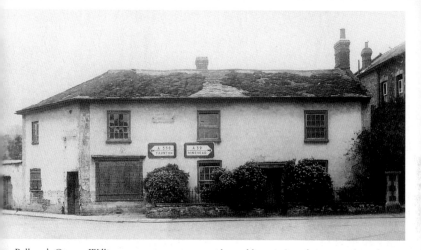

Bellamy's Corner, Williton, now an open space with a public seat. It took its name from the jeweller who ran a business here until the late 1940s, closing down, unfortunately, just before this picture was taken. Local lore celebrates it in the title of a rousing march popular with a local band, 'Slap, Bang, Wallop Up Round Bellamy's Corner'! The lads would plague the jeweller by hiding in the bushes when it was time for him to put up and bar the shutters, and then remove the bar when he went to fetch the lock. After a while he grew wise to it.

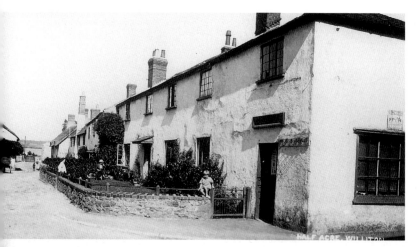

Half Acre, 1922. The little boy on the wall is Herbert Hole's son Henry, who carried on the photography business to the fourth generation. The corner shop, Churchill's saddlery, later became Lee's grocery store, then Bulpin & Isaac's.

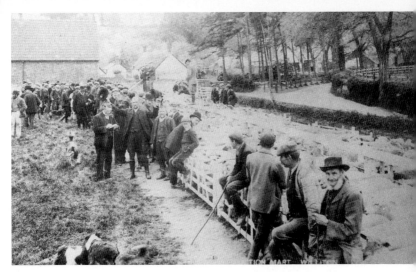

Auction market, c.1910, held on the Bury, on the corner of Priest Street and Bridge Street. The regular market ceased long ago, probably before 1939, but the site is still used to store and display agricultural machinery.

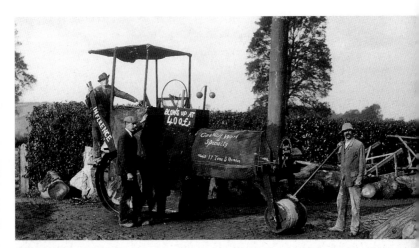

Williton Carnival, 1910. Even then, local organizations enjoyed getting in a good dig at 'Them', in this case the Council and its supposed skulduggery, with notices of 'Influence' backing 'Inefficiency'.

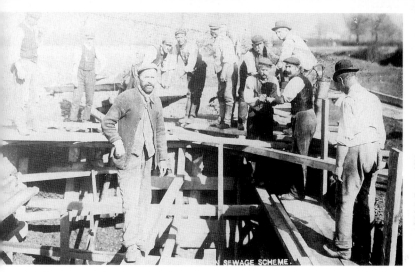

Laying the new sewer down by Long Lakes, 1920s.

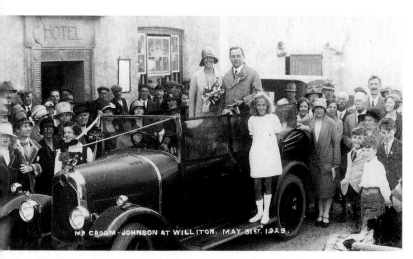

Visit of K. Croome Johnson, successful Conservative candidate in the General Election of 1929. Rosie Fowler is on the running board.

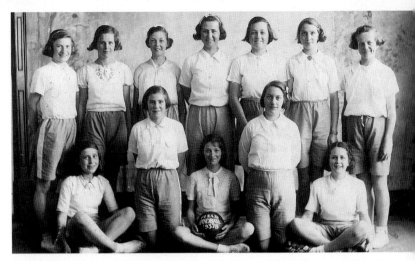

Williton Girls' field handball team, champions of the district, 1937-38. Back row, left to right: Frances Cheek, Dorothy Tarr, Peggy Hughes, Mary Bale (Binding), Yvonne Bourne (Fouracre), Joan Sweet, Dorothy Sully. Front row: Evelyn Trebble, Rita Bale, Pamela Street, Emily Tudball, Jean Bennett (Roadwater).

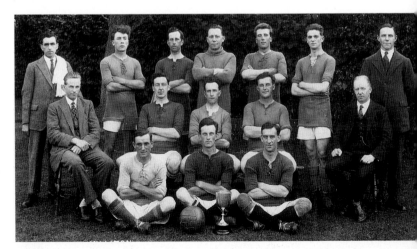

Williton Football Club, Charity Cup Winners, 1924-25. Back row, left to right: Frank Holcombe, ? Webber, Toby Sully, ? Branchflower, Derrick Routley, Alec Davis (Watchet), Reg Branchflower. Middle row: Cyril Woolley, Ted Conibeer, Rufus Sully, Bert Lyddon, Frank Cox. Front row: Jack Tuckfield, Clifford Ashman, Jack Chidgey (Watchet).

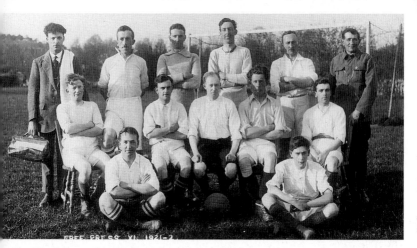

The West Somerset Free Press, with its staff of roving reporters, compositors, printers and engineers, could regularly muster a team to compete in the local league. Here, in the 1921-22 season, are back row, left to right: Jack Farthing, Ray Farrar, Reg Davis, Ted Conibeer, Bill Hurley, Fred Rich. Front row: Tom Chidgey, Walter Ashman, F.N. Cox, Ron Farrar, Ted Stevens. Seated: Bill Court, ? Bulbin (Tower Hill).

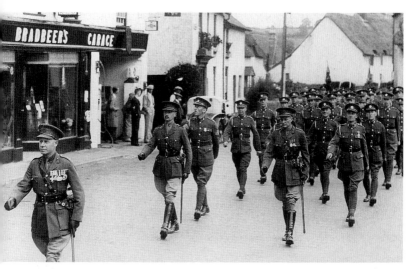

Church parade of Territorials from Doniford Camp, c.1936, led, it is thought, by Captain James Lang.

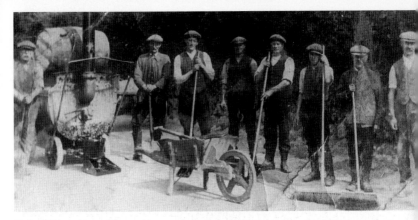

In the 1920s upkeep of the roads cost a penny for every pound spent today. There were plenty of cars around – several hundred a day on the A39 – but none of the juggernauts which do a thousand times more damage than the heaviest car. Resurfacing, usually of short stretches, was done by tipping the tarmac from a cart or lorry, spreading it with rakes and shovels, and levelling it with a steam roller. By the end of the day the heat had made the men's feet raw. The Williton Rural District Council's road gang sometimes parked their tar boiler in a cracking-yard (still to be seen) at the top of the rise from Dragon's Cross, and a line of bricks set into the stone wall marks the height to which the stone-cracker's traditional 'yard' of stones was piled. The roadmen are, left to right: Tommy Hawkes (foreman), Charlie Watts, Harry Watts, F. Holcombe, William Gard, L. Headford, J. Chidgey, F. Hill.

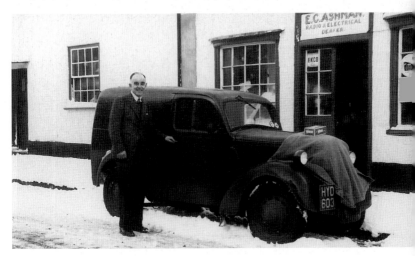

Ted Ashman outside his electrical shop in Long Street, 1972.

Men of the Williton Branch of the (Royal) British Legion in R.C. Sheriff's *Journey's End* in March 1932, a performance still remembered after more than sixty years by some of those who witnessed it. Here Sergeant-Major (W. Burnett) interrogates a German prisoner (Ted Ashman).

The cast of *Journey's End*. Left to right: E. Ashman (Prisoner), R. Clarke (Soldier), ? Cluett (Lt Hibbert), G. Harrison (Lt Trotter), Harold Geen Williams (Lt Osborne – Uncle), Frank O. Pratt (Capt. Stanhope), Jack Hurley (Lt Raleigh), J. White (Colonel), Claude Gooding (Capt. Hardy), W. Burnett, of Nettlecombe (Sgt Major). H.V.G. Williams was a contractor in Watchet, Frank Pratt the Washford schoolmaster, Claud Gooding a Washford miller, and Jack Hurley became editor of the *West Somerset Free Press*.

The Queen Bee, a radio-controlled target-towing aeroplane first tested at the ack-ack range at Doniford in 1938 and about to be catapulted into the air.

A practice shoot at Doniford, 1938. With shells at £5 a time they were not allowed to blaze away for the fun of it!.

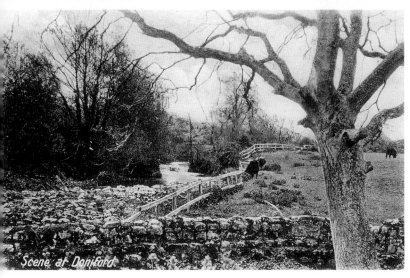

Doniford. This view, or something still like it, takes a little searching for, but is worth the time and trouble.

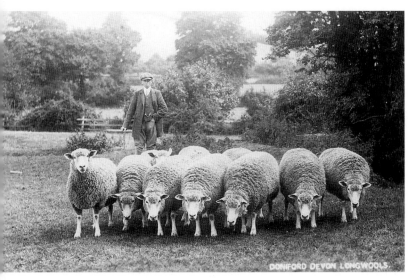

Doniford farmer with Devon Longwool sheep, *c.*1920.

Sampford Brett, 1920s.

Stogumber, *c.*1910. The White Horse was then a 'Family Temperance Hotel'.

Roadwater, Luxborough and the Hill Country

A Stroll Up Through the Longest Village in West Somerset

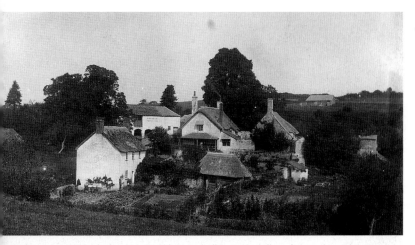

Golsoncott, c.1890, nestling comfortably in its hollow in the hills and somewhat richer in trees than now. The scene was photographed by Daniel Nethercott's son Rudolph and repays a visit to see the changes made in a hundred years.

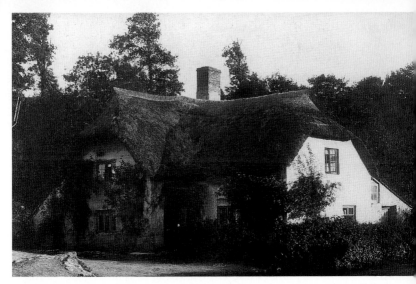

Riverside Cottage by the ford in Lower Roadwater, c.1890, with one of the newly-installed oil lamps on the left. The cottage embodied all the picturesque charm of its type but was also dark and damp to live in and subject to flooding. The cart tracks show the state of a country road even in the summer.

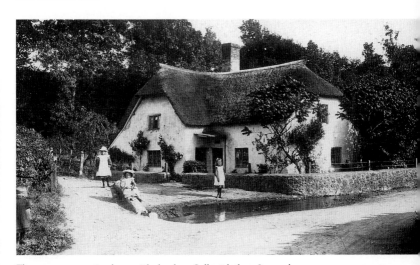

The same a generation later, with the three Sully girls from Lowood.

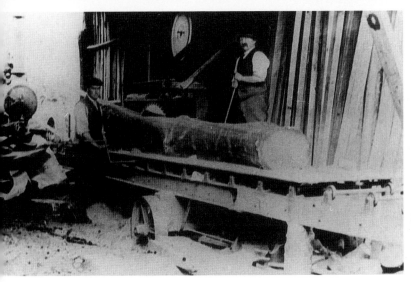

Nethercott's sawmill, Roadwater, *c.*1920. Harry Nethercott (top sawyer) and Fred A. Bond.

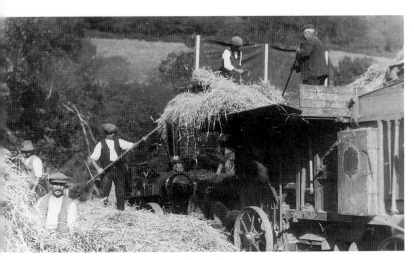

Threshing below Harper's, 1950s, with Walter Nethercott on top.

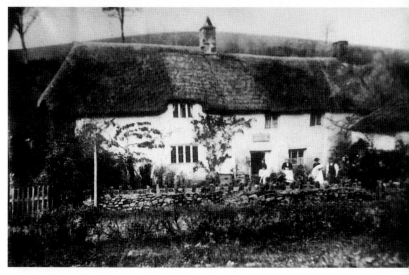

Roadwater Inn, c.1880, run by William Willis and family.

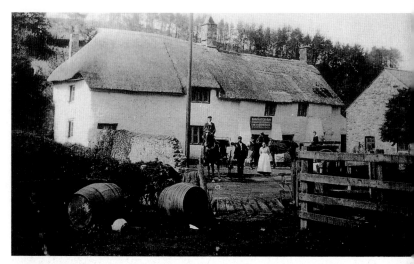

The same about twenty years later, after the telegraph had come to the village (though for the post office only). A way in for carts and drays has been made and a plank bridge laid over the leat coming down from above Roadwater Farm.

Lower Roadwater, 1920. The inn is to the left of the barn.

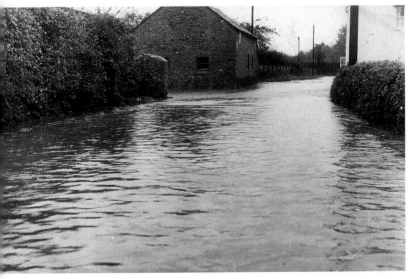

The village in the floods of October 1960.

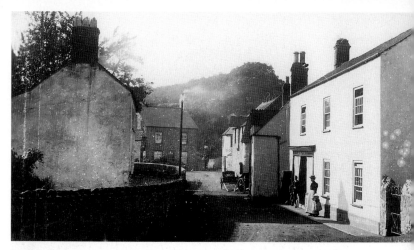

Looking up the street toward the Bridge. The trap with shafts on the ground shows that the smithy is now open for business, and a notice behind it, painted on the wall of Bridge Cottage, announces the Williams saddlery.

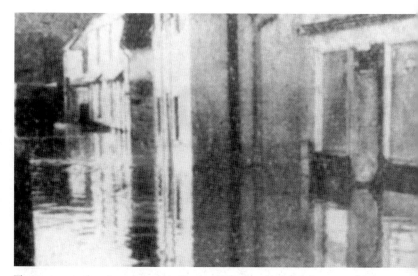

The same scene when the waters rose in October 1960. One elderly lady living over the river had to be rescued through an upstairs window.

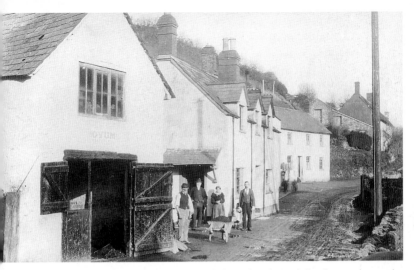

The blacksmith's door is opened wide, but Tom Slade is taking his ease, hands in pockets, with his wife Eliza, son Jim, and probably a little nephew in 1901 or 1902. Eli Vickery (?) straightens his back and looks on.

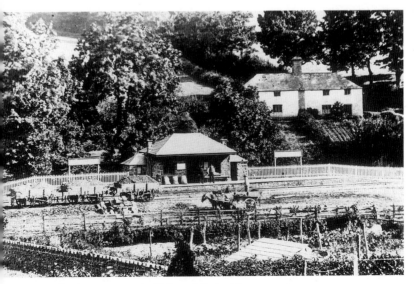

The mineral railway station in the 1870s, with Richard James as station-master.

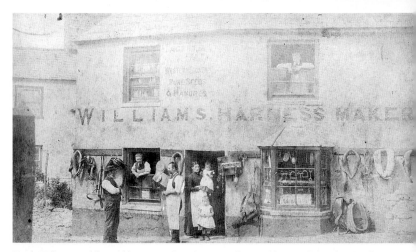

Frank Williams, saddler and harness maker, chatting with a neighbour at the Bridge, Roadwater, c.1900. Horse collars, bits, pairs of hames, reins and bridles, all the saddler's craft, are on display.

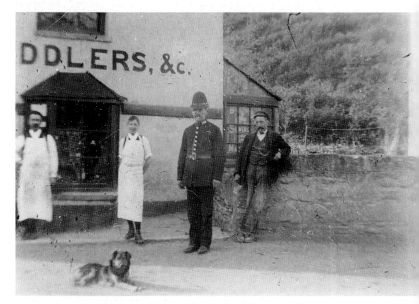

A slightly older Frank and son pose with the policeman from Washford. John Voss, mason, does a quick check of the strength of the parapet of the bridge.

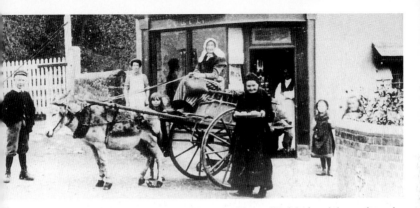

One of the most familiar figures was Granny Burnett of Stouts, Washford, with her traditional striped pinafore and donkey and greengrocer's cart. She has stopped to make a sale outside Roadwater Post Office to Granny Willis, while the postmaster, W.G. Court, looks on.

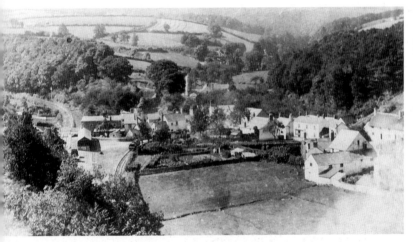

Looking down on the centre of Roadwater from the top of Harpers and Yeaw Hill on a warm, slightly hazy summer day in the early 1890s. Nothing is moving on the mineral line – note the signal at the edge of Road Wood – and the Oatway crossing gates are closed. The siding leads to the coal yard. Even at that time the barn on Scrubbet (between the two great oaks) was a ruin. The white vertical strip in the centre is the Luxborough road, and beside it one can just see the roof of the old chapel (now also a ruin) and the club room of the Valiant Soldier. On the far right, on Knap, is the thatched New Inn, and below it are Mill House and the mill, the leat from it running athwart Day's Meadow (now raised and walled here) to rejoin the stream. Station Road (or Proud Street) runs straight acorss the picture. An idyllic scene; one could not say the same for...

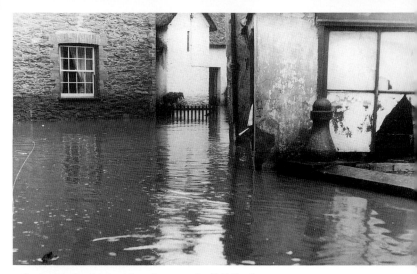

... Station Road under three feet of water in the 1960 flood.

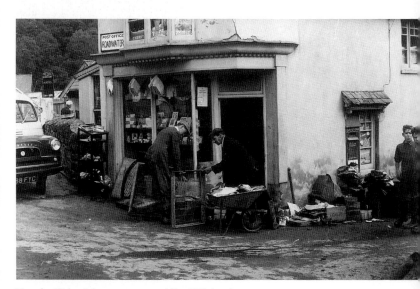

Next day Walter Lile, postmaster, and David Taylor clear up.

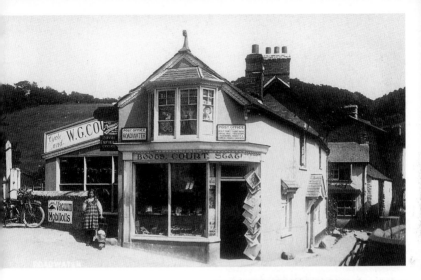

Above: The post office in 1913, a date indicated by the postmaster's $3\frac{1}{2}$ hp James motor cycle, registered in that year but soon exchanged for another. As well as transacting postal business he sold boots and shoes, which everyone needed, and cycles, which many were learning to want.

Right: William George Court (1876-1953), postmaster from 1900 to 1920.

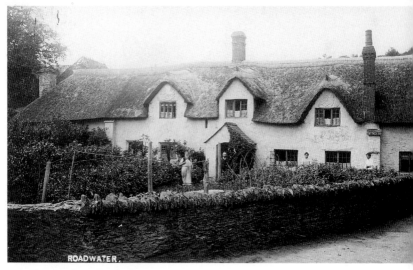

Oatway House, the oldest dwelling in the village, built (or renovated) by William Oatway in 1700 as a dowry for his daughter.

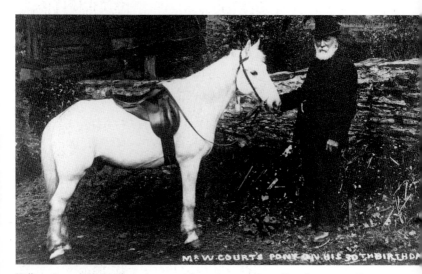

William Court (1847-1929), cordwainer and preacher, with one of his white ponies, Dapper, on the pony's thirtieth birthday.

Above: Croydon Hall Club House, built by Count Hochberg for the people on his estate but destroyed by fire.

Right: Count Conrad von Hochberg (right) with his secretary, c.1910. The Count was a relative of the Kaiser but a fervent admirer of England. He bought Croydon Hall in 1908 and soon proved himself a good landlord and considerate employer. He returned to Germany two days before the outbreak of war in 1914, and in the anti-German fever of the time was attacked most shamefully. In Germany he served in the Red Cross. He could never return here, lost his English estates and, it is said, died a broken-hearted man.

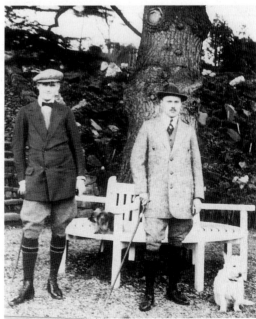

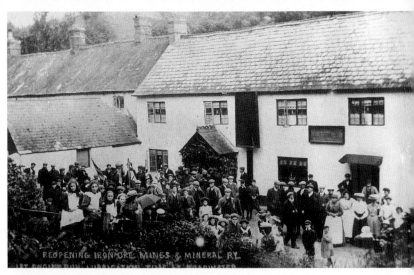

Crowd at the Valiant Soldier on the day the mineral railway re-opened in 1907.

In 1938, after Neville Chamberlain's return from Munich, a by-election was called in West Somerset. Vernon Bartlett, a most distinguished foreign affairs commentator and correspondent for the *News Chronicle*, stood as an Independent Progressive, and the Liberal and local Labour parties stood aside and supported him. He fought the election strictly on foreign policy and the need to stand up to Hitler, and won. Vernon Bartlett served as an effective and much appreciated MP throughout the war and until 1950. Here he is addressing a small gathering in Roadwater in the 1945 General Election. Left to right: Harold Scholfield (agent), ? Shopland (Golsoncott), Peter Burnett, Harry Burnett, Joe Webber, Mrs Bartlett, Vernon Bartlett, Mrs Chidgey, Colin, Mrs K. Lile, Mrs Western, -?-, Evelyn Furze.

This cottage (seen here in the 1880s) is thought to have stood near the stream in Tacker Street, but was demolished not many years after the photograph was taken.

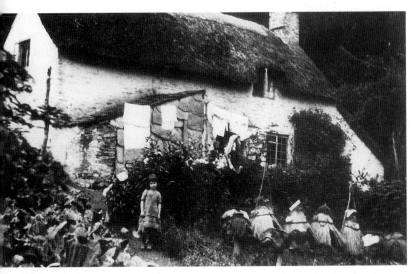

This old cottage in Leigh Woods, last lived in by the Sowden family, was abandoned in the 1960s but is still standing.

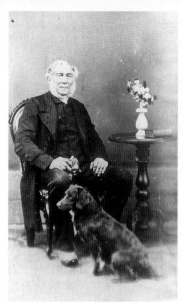

Four Village Victorians:
George Sully, farmer.

Daniel Nethercott,
mason and photographer.

Thomas Bryant,
miller, Roadwater Mill.

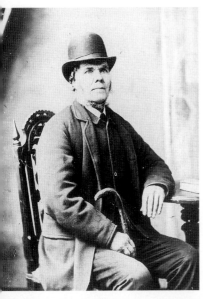

James Staddon,
sexton and parish clerk, Treborough.

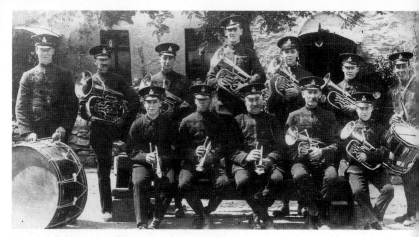

Roadwater Band, 1920s. Back row, left to right: Fred Taylor (from High Park), Harry Vickery, Harry Burnett, ? Figgis, Harry Nethercott, Walter Taylor, Harry Hemmett. Front row: Edmund Burnett (from Hayne), Bill Ridler, Tom Ridler (Bandmaster and father of Bill and Reg), Sidney Duck, Reg Ridler. This photograph was probably taken at Vale Mills. Bill Ridler used to play the Last Post at the war memorial, Dragon's Cross. Reg Ridler later taught all his ten sons an instrument and formed them into a brass band.

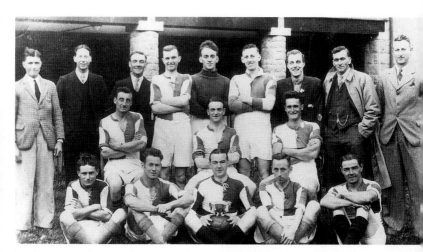

Roadwater football team and committee, champions 1935. Back row, left to right: -?- , George Takel, Harry Hemmett, ? Lewis, Roy Davis, -?-, Tom Webber, -?-, Tom Reed. Middle row: Harry Burnett, Alec Davis, Charley Burge. Front row: Norman Chorley, 'Nobby' Taylor, Dennis Smith, -?-, Hubert Westcott.

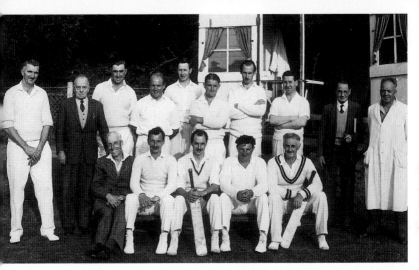

Roadwater cricket XI, c.1950. Back row, left to right: Sid Bircham, Harold Gooding (President), Michael White, Bernard Coleman, John Hill, Geoff Clatworthy, John Baker, Arthur Takel, Sydney Lile (scorer), Harold Male (umpire). Front row: Tom Webber, Bryan Lile, Derrick Lile (captain), Tom Griffiths, Harry Grimshaw.

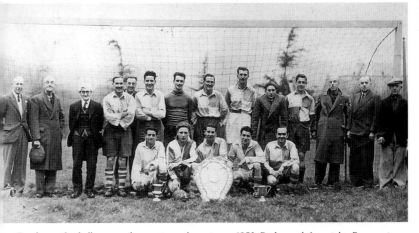

Roadwater football team and committee, champions c.1950. Back row, left to right: Perce Sowden, Harry Hemmet, Tom Williams, Gordon Eveleigh, Harry Burnett, Ken Beaver, Derrick Lile, Cliff Milton, Sid Bindon, Jock Murray, Peter Burnett, Tom Webber, Harold Gooding, Alan Burnell. Front row, left to right: Fred Tarr, Cliff Beaver, Arthur Takel, John Cridland, Bobby Yeo.

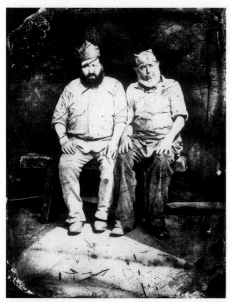

Left: Two Roadwater carpenters, *c.*1880, wearing the paper caps of their trade, now familiar only from *Alice in Wonderland*.

Below: John Lyddon, hill-country postman, *c.*1910. His round took him sixteen miles on foot, six days a week, in all weathers, and he was never known to miss a day. A stickler for the rules, he nevertheless enjoyed independence of mind and freedom of speech and took pleasure in standing up to the 'petty tyrants of the fields'.

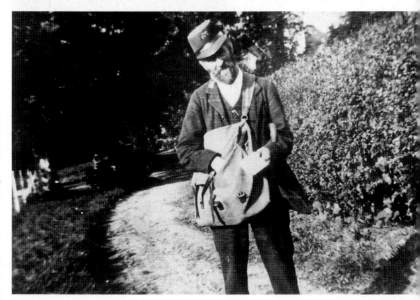

Frederick W. Vickery, a Luxborough dealer in the 1890s, was one of the first men in the valley to own a motor cycle, on which he travelled the Brendon Hills photographing farming families. This snapshot of him in 1920 by James Randall of Bishopston brings out admirably the character of the thatched cottages at the foot of Jumper's Steep.

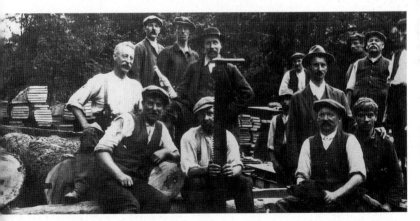

Portuguese troops served on the Western Front between 1914 and 1918 and suffered badly. Other Portuguese came to England. Recruiting for the slaughter in France had so reduced the number of men employed in forestry that woodmen were brought over from Portugal to get the work done. Locally they were employed on North Hill, Minehead, and at Dru'combe, in the Luxborough valley. They seem to have slept in nearby huts but they came down to Roadwater once a week to visit the post office and send part of their wages home to Portugal. For the village folk they offered a romantic glimpse of a distant land they could never have hoped to see for themselves.

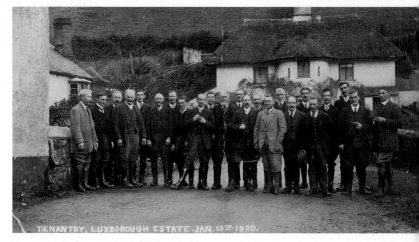

Tenants of the Chargot estate, 1920.

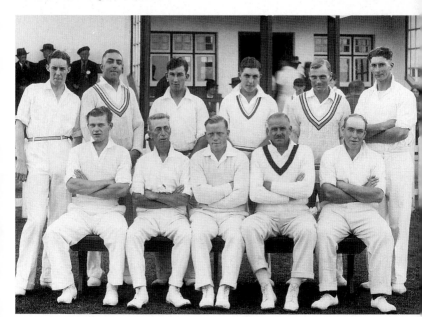

Luxborough Cricket Club, 1930. Back row, left to right: E. Taylor, R. Pallet, N. Cawsey, F. Coles, W. Bond, H. Jennings. Front row: R. Coles, F. Webber, J. Smith, D. Davis, M. Langdon.

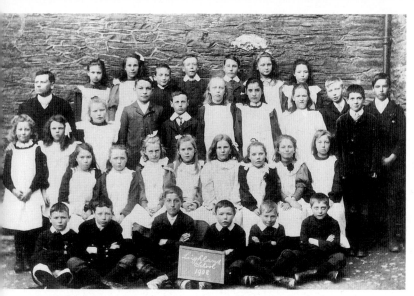

Leighland School, 1908, with their redoubtable headmaster, Edwin Reynolds.

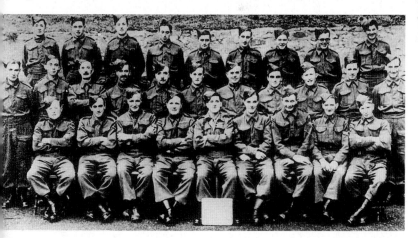

Kingsbrompton (or Brompton Regis) Home Guard, 1943. Back row: R. Stevens, E. Davey, R. Thomas, E. Howe, J. Hayes, W. Williams, W. Yerbury, R. Hole , H. Davey. Middle row: H. Toze , H. Norman, E. Lock, H. Hayes, H. Evett, R. Gale, J. Hancock, A. Hole, T. Salter, G. Hayes, G. Snell. Front row: J. Hawood, E. Coleman, W. Davy, J. Vaulter, J. Parsons, S. Gibbs, G. Snell, L. Norman, W. Lock.

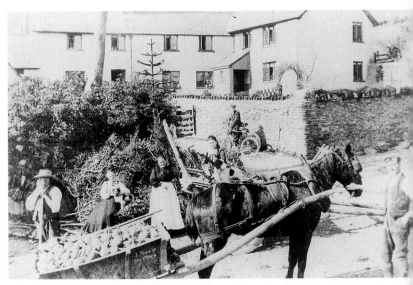

Gupworthy Farm. The Norman family receive a visit from the photographer Fred W. Vickery in 1910.

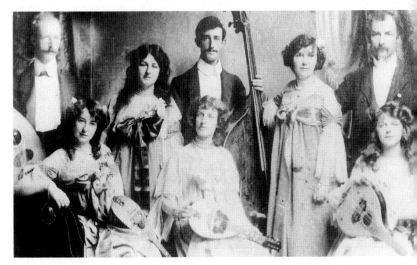

The Walford family from the Stowey area, popular entertainers throughout the district in Edwardian days. Their elegance and musicianship were much admired.

Eight

Western Wheels

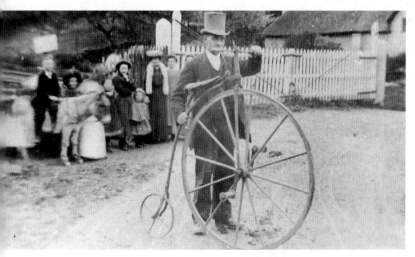

Nothing widened the horizon of the Victorian country-dweller in the early twentieth century more than the bicycle. First on the scene were the 'penny-farthings', but few of these contraptions found their way into our country districts. They cost too much for country pockets and would at best have given rough and dangerous riding on the steep, unpaved roads. John Bond, the animal doctor of Roadwater, quickly saw their advantage, however. He had one made by the village blacksmith, George Edbrooke, and rode it confidently – solid handlebar, iron-based saddle, iron tyres, no brakes! – on his rounds for twenty years. The story goes that it once took three riders at a time down a steep hill – one on the mounting-step, one on the saddle, and the young brother on the handlebars playing a concertina – but a large stone in the road 'made 'em get off a sight faster 'n they got on.'

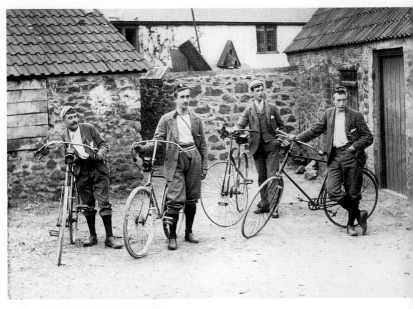

Above: Unlike the 'ordinary', the 'safety model' soon caught on, even here. The cost, around £4, was eight weeks' wages for a farm labourer and might seem prohibitive, but he would pay off a couple of shillings a week, and his daily journey to and from work, which might have taken him more than an hour each way, now took only ten to fifteen minutes. Before long young men and women in occupations less strenuous than farm work were finding cycling a pleasure and forming local clubs, like these young men of Williton. Their identities have, so to speak, cycled round the corner of Time.

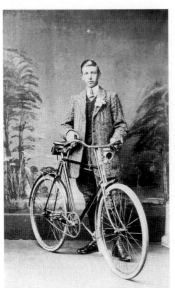

Left: Fred Andrews Bond, proud owner of a brand new cycle. The lamp is powered by carbide, which cost 4d a tin. When electric lamps came on the market many older cyclists kept to the old carbide lamps: they took a little preparation but gave brighter, clearer light.

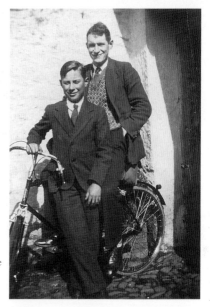

Right: By 1930 the cycle had become an efficient and energy-saving machine. The brothers Lewis and William Murrell, from Roadwater, more than once pedalled the 177 miles from London to home between dawn and dusk of a summer's day.

Below: Dr Charles Killick bought his first motor cycle, a 1½ hp Werner, in 1909, so this is a later acquisition. Rural health centres had scarcely been thought of, and from his home and surgery in Williton he covered an extensive practice on his motor cycle combination, holding surgeries in rented rooms in cottages five days a week, whatever the weather.

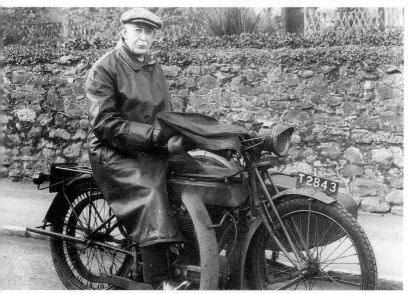

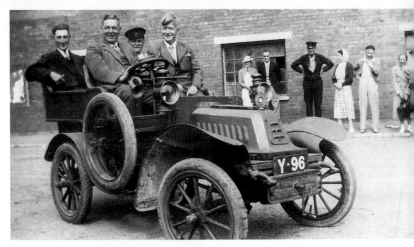

Not Watchet's first sight of a car: to judge by the bystanders this is about 1930. This 8 hp De Dion Phaeton, tonneau dark green with black and light green lines, originally belonged to a Thomas Stockham of Bridgwater, so perhaps he is the driver. At any rate, he has a suitably veteran passenger in Will Lee, doyen reporter and president of sporting associations.

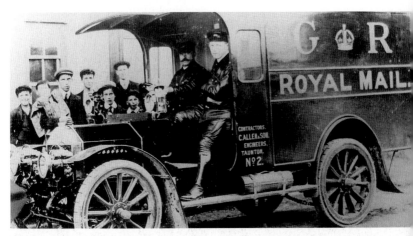

The first motor mail van into Williton from Taunton head office (c.1904) draws a small but appreciative crowd – but a cold coming the postmen had of it. Discipline for postmen while on duty was very strict: full uniform with coal-scuttle hat (later peaked cap), highly polished black boots, and no smoking on pain of dismissal. After the Great War, as it was called, most newly recuited postmen were ex-servicemen.

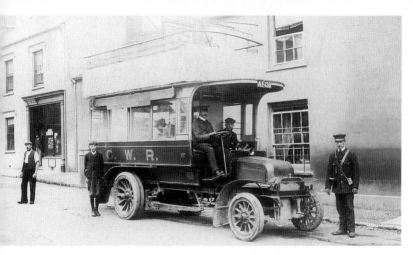

The Great Western Railway Company had thoughts of building a line from Bridgwater along the coast to Watchet to link up with the existing Taunton to Minehead branch, thereby cutting fifteen miles and ninety minutes from the journey for travellers from the Midlands. Nothing came of this, but they quickly realised the possibilities of motor transport and set up a road service from Bridgwater. This bus is waiting in Nether Stowey.

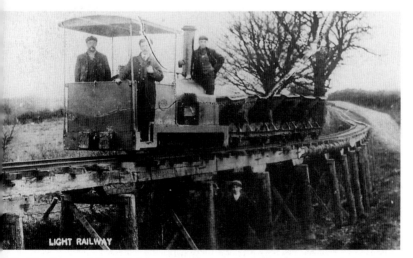

LIGHT RAILWAY

The West Somerset Mineral Railway never quite reached the altitude of the trans-Andean line, but in 1908 this little 0-4-0 Bagnall engine was hauling iron ore along the top of Brendon Hill at 1,200 feet above sea level.

A British Legion 'Beanveast', 1935.

Acknowledgements

I should like to record my gratitude for help received to:
my wife, for putting up with the frequent absences of body and mind (and the even more
unpredictable presence!) entailed in the compilation of this book;
David Harbottle and the volunteers of Allerford Museum for their courtesy and willing
co-operation on so many occasions, and for the loan of photographs
and invaluable help in identifying the characters who feature in them;
David Bromwich of the Somerset Studies Library
for copies of photographs and access to his files of the *West Somerset Free Press*;
and for the provision of materials and the sharing of their time and knowledge:
Mmes Margaret Beaver, Mary Binding, Hilary Binding, Margaret Bolt (née Shepherd),
Vera Chilcott, Joan Collins (née Bond), Yvonne Fouracre, Bridget Hill, Penryn,
Margaret Gould, Jean How, Jennifer Inglis, Margaret Morgan (née Burnett), Abby Morrill,
Phyllis Redd, Mrs Jennie Thompson, Grimsby, Mrs D.M. Waby, Mary Rawle (née Davey);
Messrs Ted Ashman, Jack Binding, Derek Cridland, Rodney Ettery,
Adam Green and the staff of the Somerset Archive and Record Office,
Mr and Mrs John Hepper, Val Hole, Fred Hutchings, Ben Norman, David Rawle,
George Ridler, Jim Sansom, Ralph White